Remembering Mississippi

Anne B. McKee

TURNER
PUBLISHING COMPANY

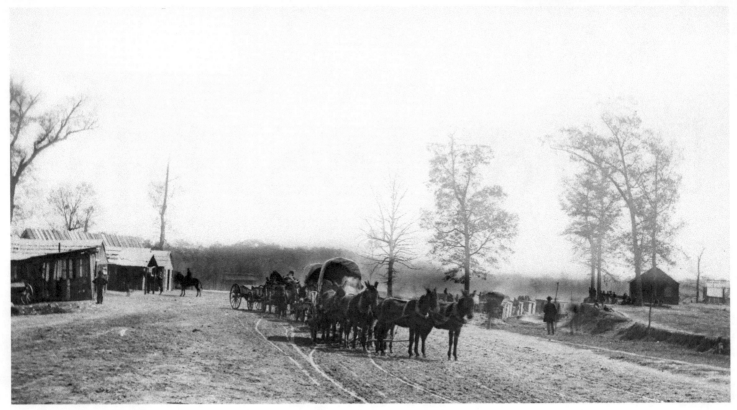

The Big Black River Station, located near Vicksburg in Warren County, is shown here in 1864 as wagons hitched to mules await the next tiresome journey. Supply sheds can be seen to the left and right of the mule teams. The Civil War would not end before another year of travail had elapsed.

Remembering Mississippi

Turner Publishing Company
www.turnerpublishing.com

Remembering Mississippi

Copyright © 2010 Turner Publishing Company

Library of Congress Control Number: 2010932642

ISBN: 978-1-59652-716-4

Printed in the United States of America

ISBN 978-1-68336-855-7 (pbk.)

CONTENTS

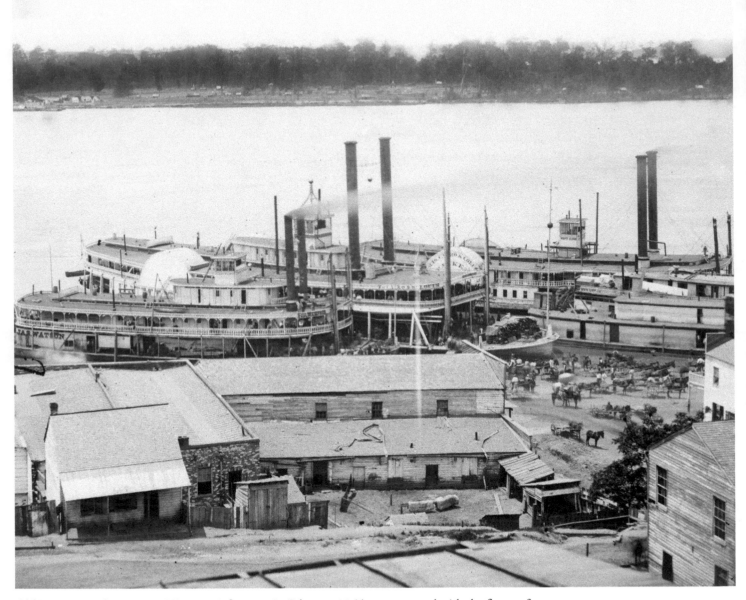

Old Man River, the majestic Mississippi, flows on in February 1864, unconcerned with the flurry of war-related activities on the levee. Steamboats are lined up awaiting the next load as mules and men prepare for the next destination.

ACKNOWLEDGMENTS

This volume, *Remembering Mississippi,* is the result of the cooperation and efforts of many individuals and organizations. It is with great thanks that we acknowledge the valuable contribution of the following for their generous support:

Lauderdale County Mississippi History and Archives
Library of Congress
Mississippi Department of Archives and History
Moore's Boler's Inn Private Collection

We would also like to thank the following individuals for valuable contributions and assistance in making this work possible:

Lauderdale County History and Archives Director Ward Calhoun, and his staff, Leslie Joyner and Janet Bunker, worked tirelessly to locate unusual and significant photos for the book. In addition, I must thank Margaret Remy, owner of Quick Prints Photography Shop, and professional photographer Keith Jacoby, both of Meridian, for their valuable assistance.

Most important was the support of my husband and family, especially my daughter-in-law, Kelly McKee, an English instructor at Meridian Community College, who spent hours providing the necessary edits needed to allow the manuscript to flow as smoothly as the Old Man River—namesake of our great state of Mississippi.

The goal in publishing this work is to provide broader access to this set of extraordinary photographs, as well as to inspire, provide perspective, and evoke insight that might assist citizens as they work to plan the state's future. In addition, the book seeks to preserve the past with adequate respect and reverence. With the exception of touching up imperfections that have accrued with the passage of time and cropping where necessary, no changes have been made. The focus and clarity of many images is limited by the technology and the ability of the photographer at the time they were taken.

PREFACE

William Faulkner, one of Mississippi's most famous novelists, once said, "To understand the world, you must first understand a place like Mississippi." Another Mississippi writer, Willie Morris, explained it this way: "Physically beautiful in the most fundamental and indwelling way, [in that] it never leaves you." A recent Mississippi advertisement said, "Mississippi. Feels like coming home." All of these sentiments are true, but they miss the sweet essence of the state and the strong spirit of the people. There is no other place like Mississippi, where the people think with their hearts and love with their souls.

History tells of the Choctaw and other tribes who once walked the land, followed by an influx of settlers who traveled by wagon to follow their dreams into the new frontier called Mississippi. To work the land, African peoples were brought to the rich and fertile ground as the property of plantation owners eager to make the land prosper. Slavery was the darkest period in Mississippi history, and the Civil War which ended it was bloody, brutal, and bitter. Natchez, the oldest settlement on the Mississippi and which had once been home to more than 500 millionaires, was largely spared the ravages of the war, but other places were not so fortunate. The capital city of Jackson, for one, was burned to the ground.

The war ended in overwhelming defeat for the South, and on its heels Mississippians weathered postwar Reconstruction, with its beaten lands and broken hearts. Losing the Civil War was not anticipated. Many Southern warriors did not come home, and without their return, those who remained were left with little more than blood-soaked memories. Nor were the emancipated people prepared for freedom. Where were they to go? What were they to do? Many returned home to live near their former owners. Some worked as tenant farmers and hired themselves out to do the same work as before the war. Together, Mississippians put their shoulders to the plow and pulled out of a desperate time.

The golden age for Mississippians (the years 1899 to 1920) brought new hope and prosperity with exciting innovations and new opportunities. Railroads continued to crisscross the state providing good jobs. Mississippians once again enjoyed the arts, music, education, and a better life. Industry grew and the land flowed with milk and honey.

Too soon the winds of war returned. Soldiers left their Mississippi homes to fight World War I, joining the war effort at Camp Shelby and heading overseas to the trenches of Europe. Ten years after the war ended, the Great Depression spread a black cloud across the United States. In Mississippi, the flood of 1927 brought hard times in advance. Once again, Mississippians worked together to sustain themselves through the calamity. The Works Progress Administration and other federal programs provided make-work jobs and many Mississippians subsisted on wild game, turnip greens, and whatever they could gather.

World War II took Mississippi soldiers overseas again, and industry kicked in to supply our armies throughout the world. Mississippi women learned skills traditionally performed by men. They filled positions in the defense industry and munitions factories, holding jobs as welders, pipe fitters, and boilermakers. Camp Shelby became the largest training camp for the army in the United States. With victory at hand and the depression a fading memory, a new era promised new hope.

As the future dawned, Mississippians could look back on a wealth of accomplishments in the Magnolia State. The first nuclear submarine built in the South was built here. The first can of condensed milk was created here. Celebrities born here include Jim Henson, creator of the Muppets; legends of music Jimmy Buffett, Bo Diddley, B. B. King, Muddy Waters, Conway Twitty, Jimmie Rodgers, and of course Elvis Presley; and actors Morgan Freeman and Ray Walston. Literary icons Tennessee Williams, Eudora Welty, and William Faulkner were Mississippians. The Dentzel Carousel in Meridian is a National Historic Landmark and tours of the antebellum homes of Natchez delight visitors to this day. The Old Spanish Fort in Pascagoula is the oldest structure west of St. Augustine, Florida, and Natchez is the oldest town on the Mississippi River. Oliver Pollock, buried near Pinckneyville, is credited as the inventor of the dollar ($) sign, and Barq's Root Beer was invented by Edward Barq of Biloxi. Of geographical interest, Jackson sits 2,900 feet directly above an extinct volcano, the only city in the United States so placed. And especially important to catfish aficionados everywhere, Mississippi produces more farm-raised catfish than any other place in the world.

Mark Twain once had one of his characters say that muddy Mississippi water is "wholesomer to drink than the clear water of the Ohio." If the sediment settles in the pitcher, he said, what you want to do is "to keep it stirred up."

We Mississippians tend to agree.

—*Anne B. McKee*

A lone soldier gazes into the distance from the banks of Chickasaw Bayou in February 1864. The bayou betrays no sign of the recent carnage. Following the engagement here, when Union forces commanded by Ulysses Grant were repulsed at Vicksburg by Confederate troops under the command of General John C. Pemberton, Grant chose to besiege the city. After 47 days, with supplies depleted and no sign of reinforcements, Pemberton's garrison finally surrendered on July 4, 1863, yielding Vicksburg to Union control. Eighty years would elapse before the citizens of Vicksburg would again celebrate July 4 as Independence Day.

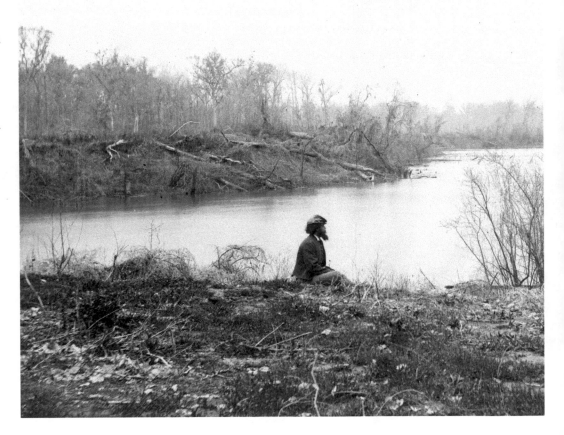

CIVIL WAR AND SURVIVAL

(1860s–1899)

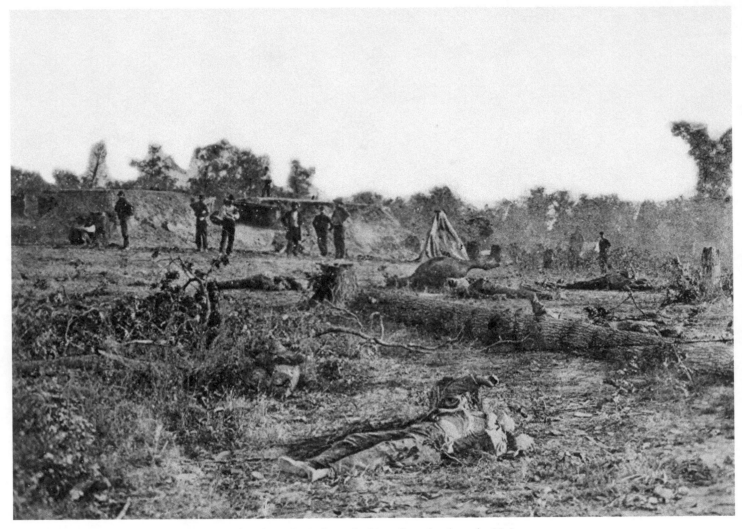

Federal determination to hold two major railroads at Corinth resulted in a fierce battle and a Union victory on October 3-4, 1862. Seen in this photograph the morning after the attack are Confederate dead and Union troops surveying the aftermath of the conflict.

The battlefield of Chickasaw Bayou, in Warren County, was the scene of a fierce struggle on December 26-29, 1862, the opening salvo of the Vicksburg campaign. Union major general William T. Sherman and Confederate lieutenant general John C. Pemberton commanded their respective troops in the swamps near Walnut Hills, where the Union defenses were ultimately repulsed. Sherman then withdrew, giving the Confederacy a victory.

The Battle of Big Black River
Bridge or Big Black, of May 17,
1863, was waged as part of the
Vicksburg campaign and resulted
in a Union victory. Confederate
forces, confused and panicked,
withdrew across the Big Black
on two bridges, setting fire to the
bridges to prevent Union pursuit.

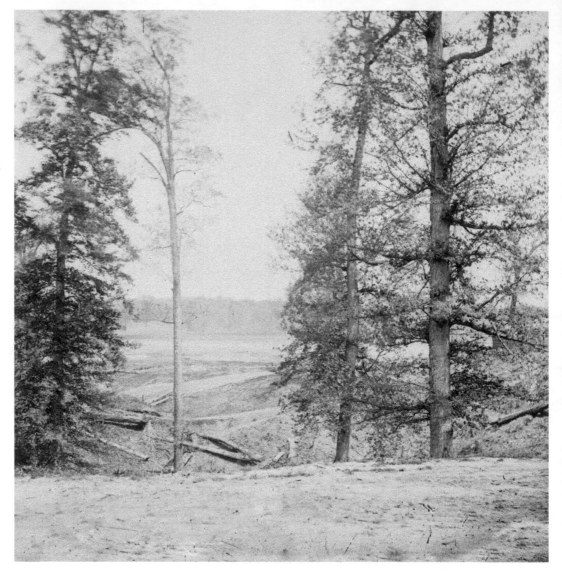

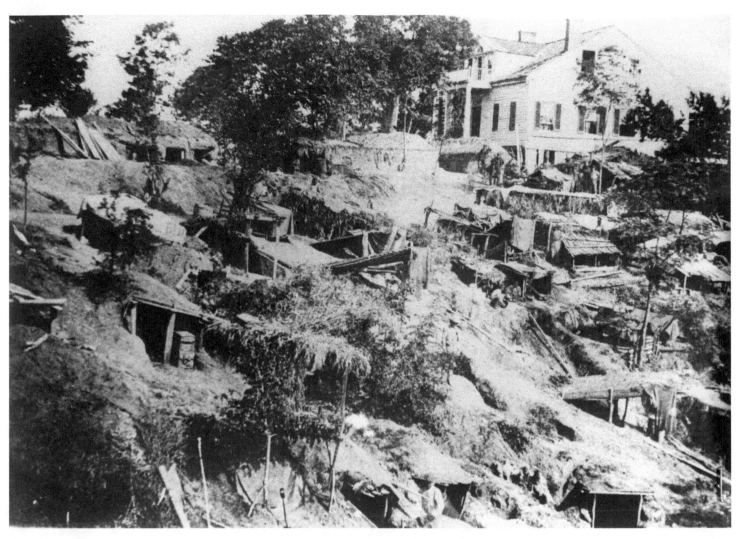

The war has ravaged the environs of this antebellum home. The scene depicts the siege of Vicksburg and how one lovely home survived. Caves have been dug and makeshift shelters erected, clear evidence of the plight of locals during the bombardment by Union forces.

Goings-on at the corner of Pearl and State streets in Jackson. The old state capitol with its dome rises in the background. When Mississippi became a territory in 1798, Natchez served as its first capital. Following statehood in 1817, Jackson, on the Pearl River, became the capital city.

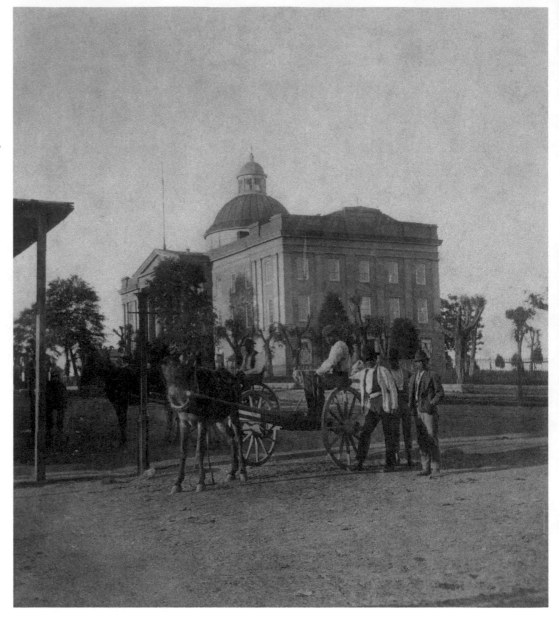

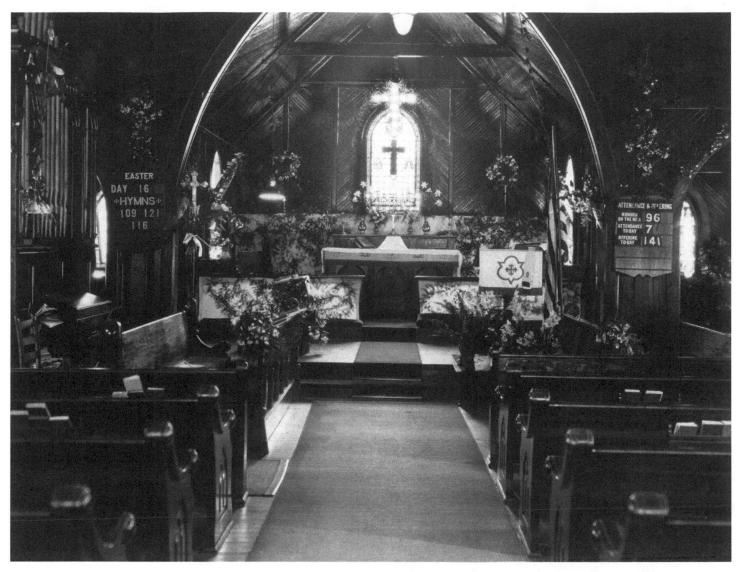

Interior view of a church in Jackson, facing the altar and pulpit, with carved wooden pews, hymnbooks, stained-glass windows, Christian icons, announcement board, flowers, and other features. The ornate beauty of the church is impressive and the sanctuary of peace it offered vital, especially during a time of war. According to the boards, Easter was being celebrated. Of 96 members, 7 had attended the most recent gathering, contributing $1.41 to the offering plate.

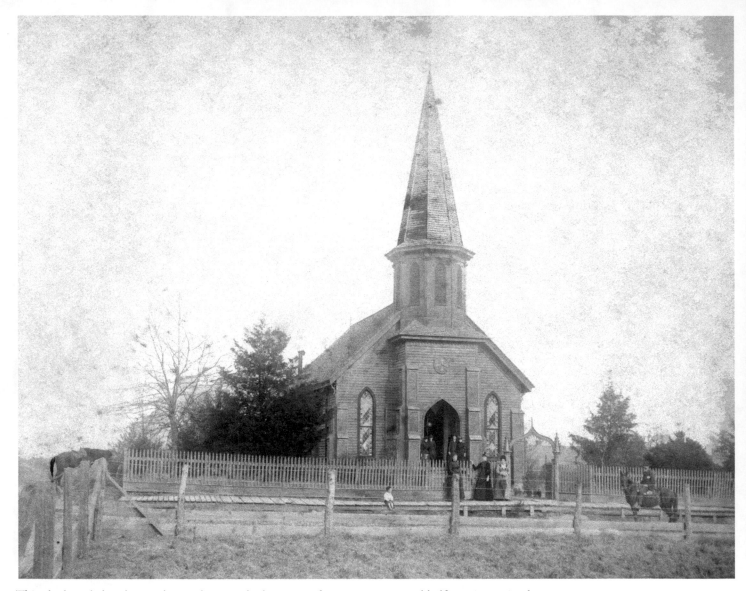

This clapboard church in Jackson, photographed in 1870, features an octagonal belfry, spire, stained-glass windows, and a Tudor arched entrance. A wooden sidewalk and picket fence front the structure, where a group of locals pose for the camera.

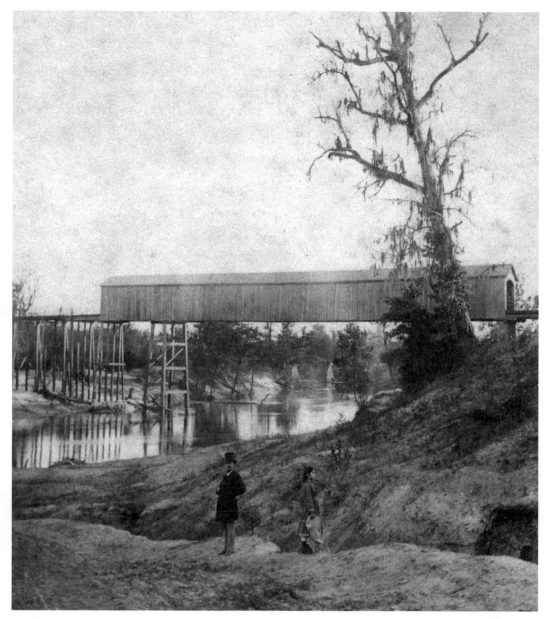

A covered bridge over the Pearl River at Jackson, with Spanish moss clinging to the tree at right. The Pearl River got its name by being an early site of French pearl fisheries. The bridge was used to corral prisoners of war during the Civil War.

The Pearl River prison bridge collapsed after the war, a 5-dollar fine for "driving faster than a walk" notwithstanding. Seen here is the wreckage, some of it submerged beneath the waters.

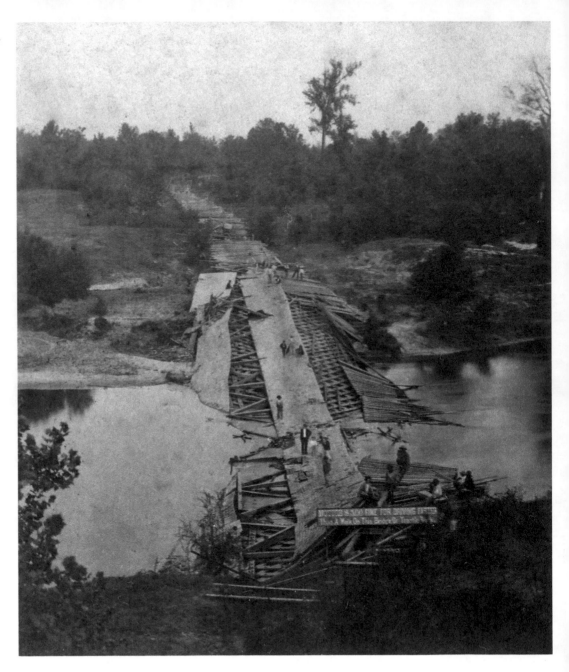

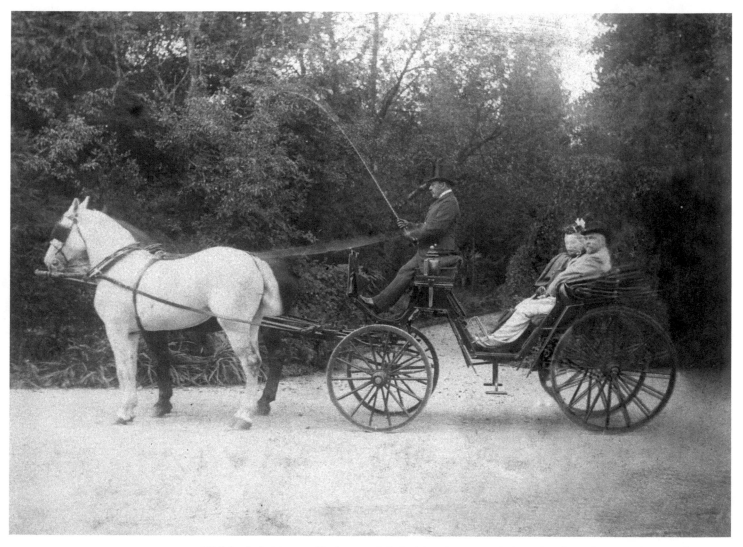

Well-heeled citizens of Jackson and their driver interrupt their outing for a photograph around 1870.

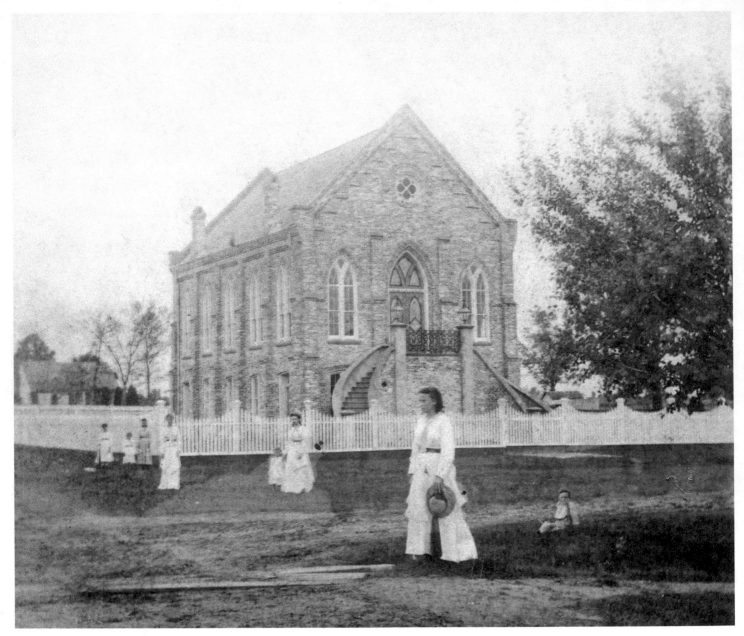

Women and children of the community dressed in their Sunday best pose in front of this two-story brick church in Jackson around 1870. To prevent blurring, camera technology of the era generally required subjects to remain motionless.

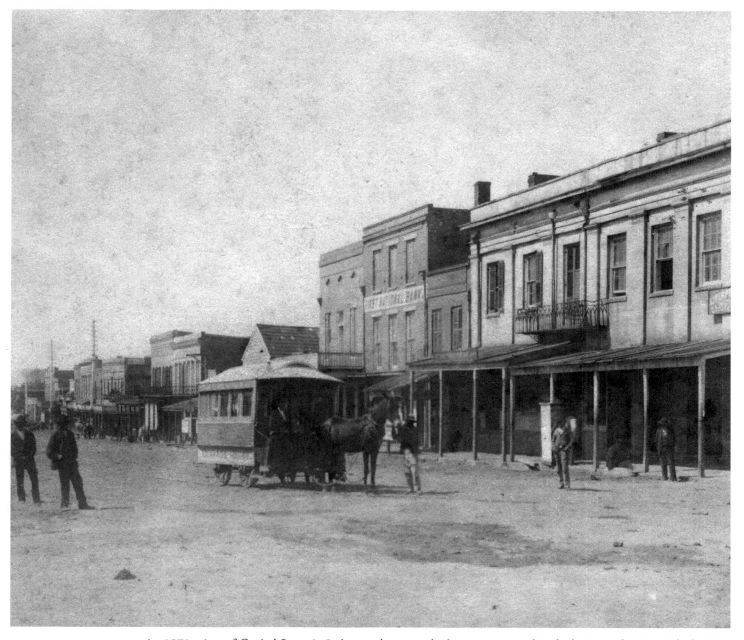

An 1870s view of Capital Street in Jackson, where a mule-drawn streetcar plies the business district, with the First National Bank visible to the right of the vehicle.

First Christian Church stood at the corner of Mississippi Street and North President Street in Jackson. Latticework enclosures protect saplings alongside the church from damage by careless horses.

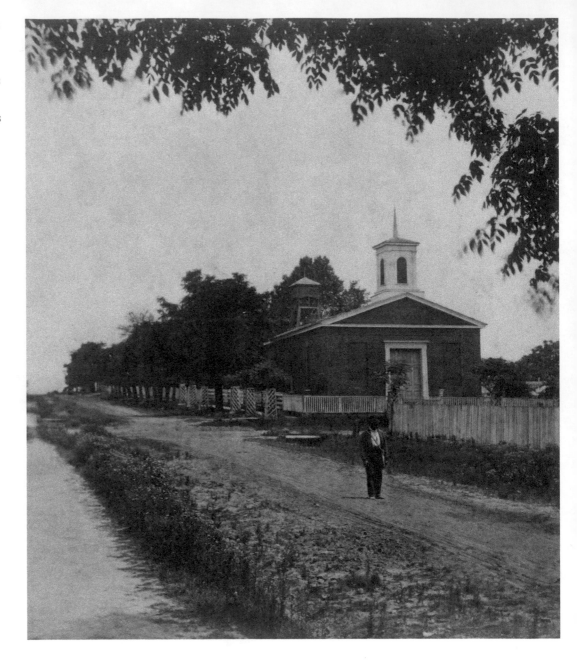

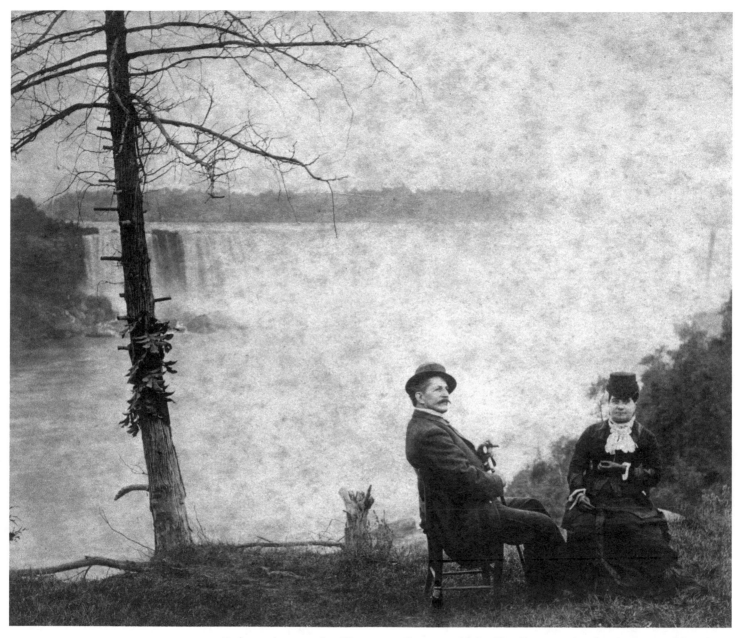

Jackson photographer Elisaeus von Seutter and Mrs. Von Seutter enjoy the vistas created by a large waterfall on September 10, 1880.

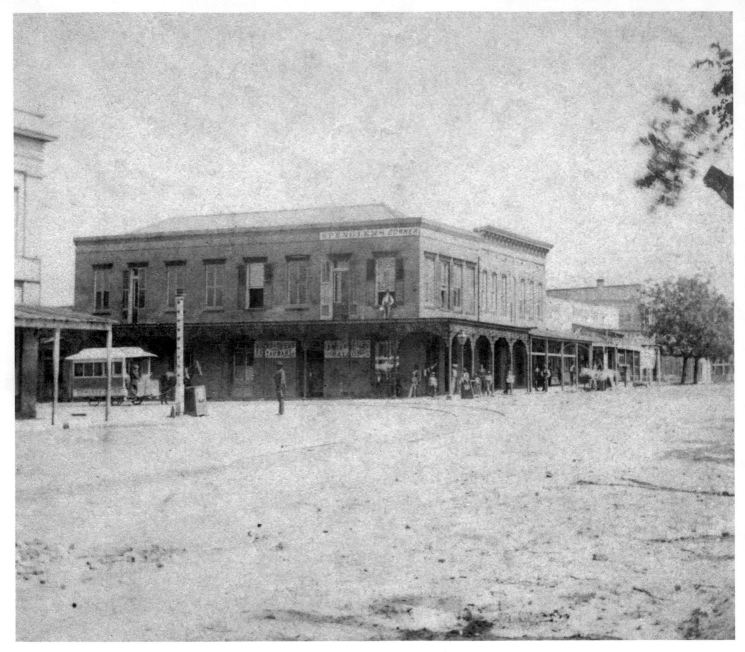

Spengler's Corner, at the northwest corner of State and Capital streets in Jackson. The Spengler brothers had opened a machine shop on State Street in 1858, lending their name to the corner.

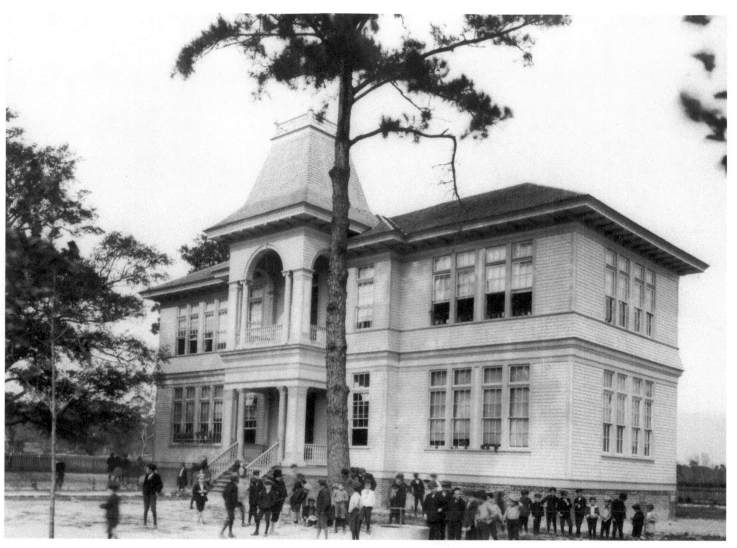

Between the years 1880 and 1910, the number of educational facilities in Mississippi increased rapidly. This two-story school, located at Biloxi in Harrison County, shows a large number of students milling about on the school grounds.

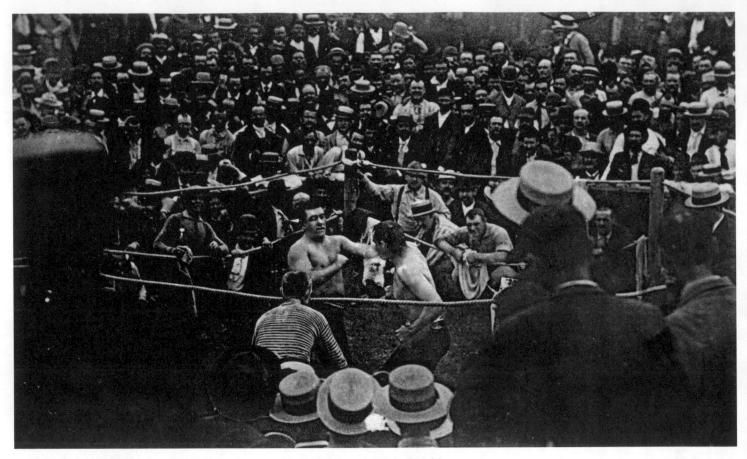

On July 8, 1889, sports history was made in the small sawmill community of Richburg in Lamar County. This was the site chosen for the last professional bare-knuckle championship boxing match in America, between heavyweight champion John L. Sullivan and the challenger, Jake Kilrain. Sullivan refused to sit between rounds, saying it was pointless: "I got to get right up again, ain't I?" After 75 rounds, Sullivan was declared the victor. The boxer became America's first national sports celebrity and the first athlete to earn more than a million dollars. This image depicts a bare-knuckle match probably held some years later.

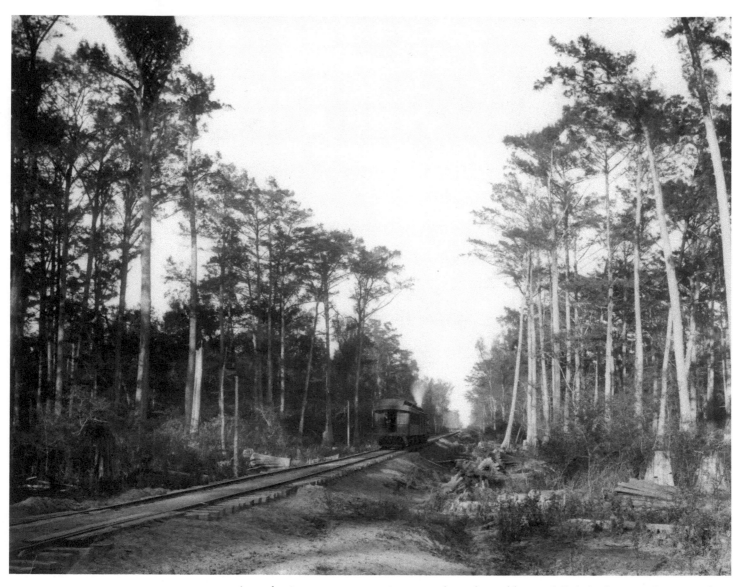

An early vintage passenger train steams through an old-grove Mississippi cypress forest, as a lone passenger gazes at the tranquil beauty of the receding scenery from the platform of the observation car. The cypress has long been admired for its majestic stature and longevity.

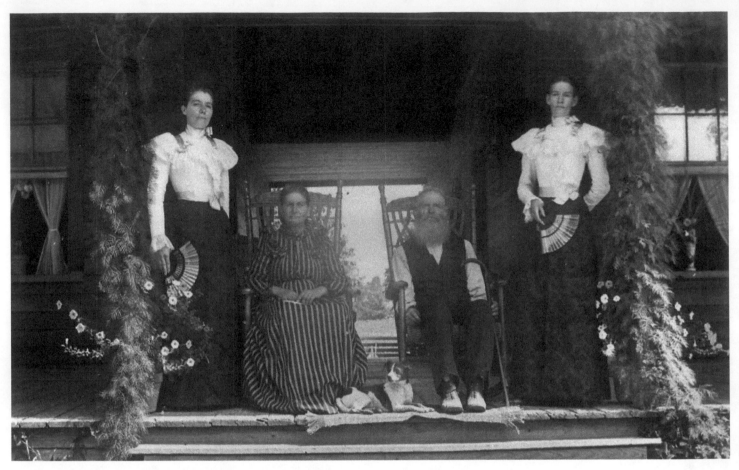

The lovely Kittrell sisters stand for a family portrait beside Mom and Dad on the front porch of their east central Mississippi home in 1889. To each side are potted petunias and what appears to be the red-flowering cypress vine, both annuals still popular among gardeners today.

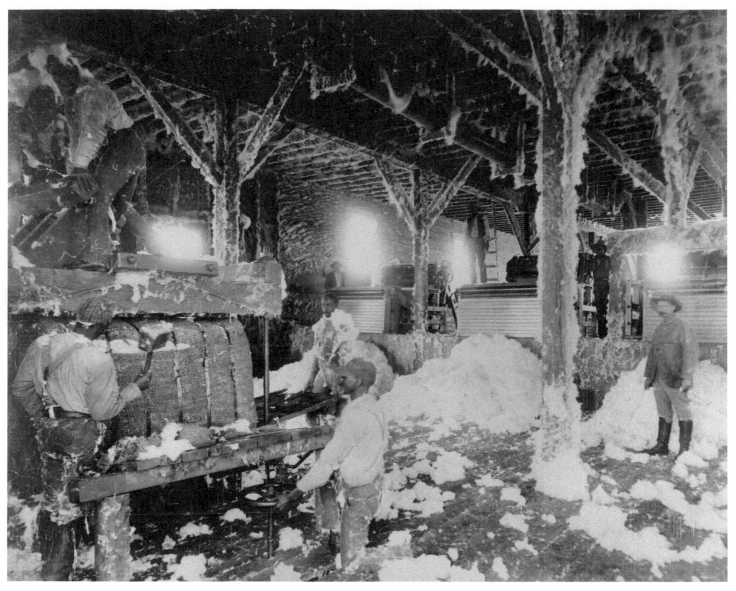

Workers in the Bolivar County town of Dahomey refine cotton in 1890 using a cotton gin. Cotton remained a mainstay of agriculture in the state long after the Civil War ended, aided by labor-saving devices like the gin. With cotton fibers clinging to everything in this image, state fair goers may derive a much greater appreciation for a state fair favorite—cotton candy—so aptly named.

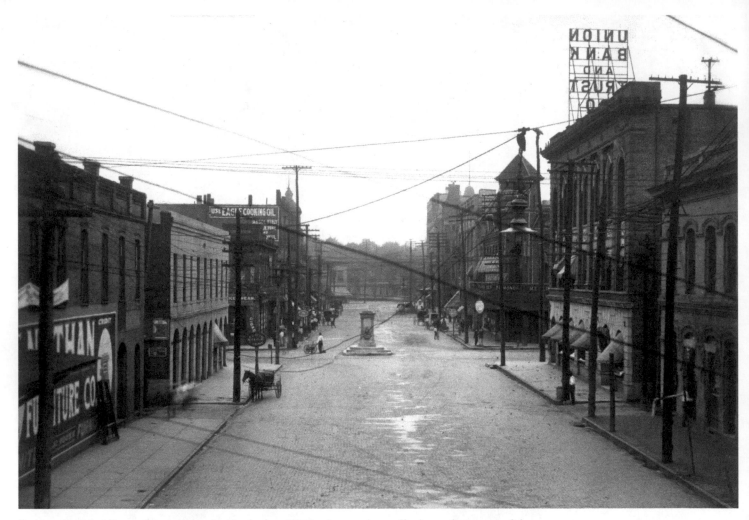

Downtown Meridian early on a morning in the late 1800s. An artesian well adorns the center of the street as a street sweeper pushes his cart and broom. Electricity was a new reality for the east central Mississippi city, and power lines are visible everywhere crisscrossing and dangling from power poles to buildings.

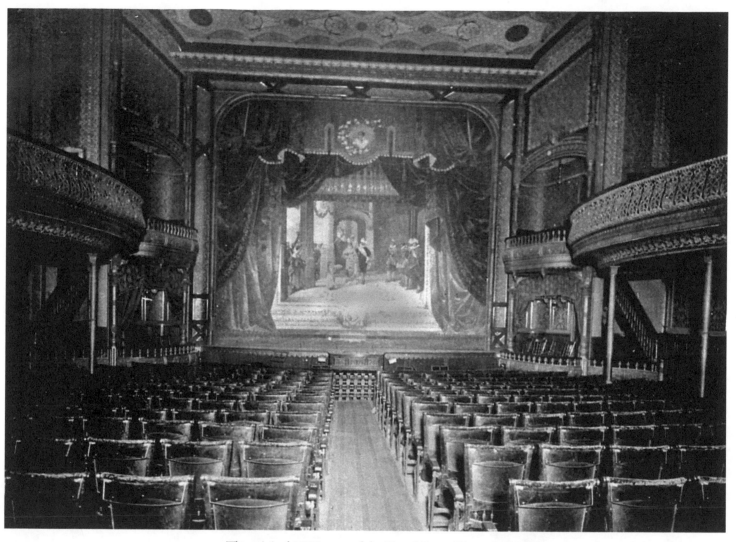

The original 1890 stage of the Grand Opera House in Meridian. At 30 feet wide by 50 feet deep, the stage could accommodate the largest, most lavish shows from New York. Under the 35-foot-high arched proscenium was an ornate painted border, which featured the famous "Lady." The Lady eventually became the symbol of the Opera House.

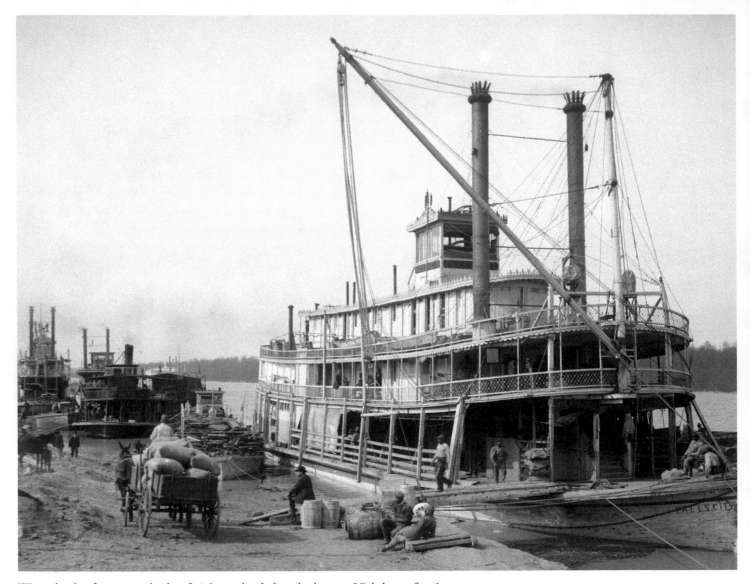

Wagonloads of cotton and other freight are hauled to the levee at Vicksburg, for river transport north and south on the Mississippi River. The *Falls City,* in the foreground, and other steamboats are anchored wharfside awaiting cargo.

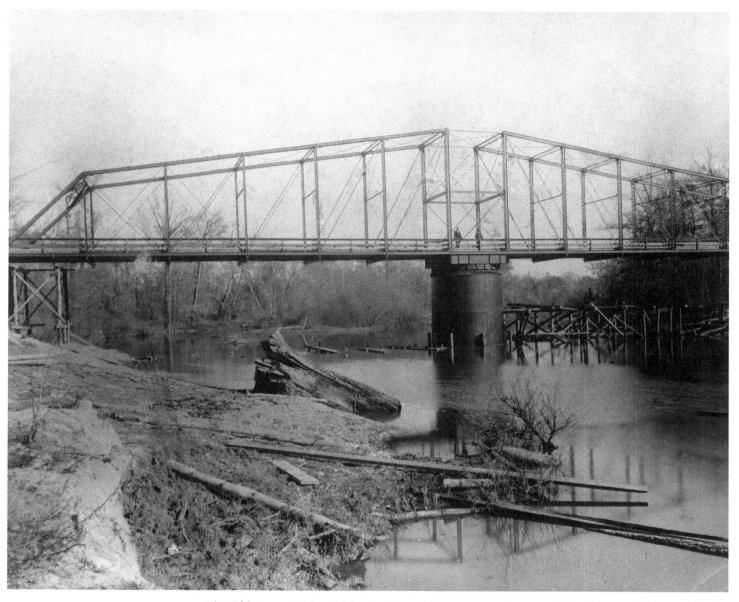

The Old Amory-Bigbee Bridge, in Monroe County, soon after completion in 1899. The swing bridge spanned the Tombigbee River, part of a regional transportation network of bridges built between 1880 and World War II that relied on techniques devised for bridges built to span the Mississippi River.

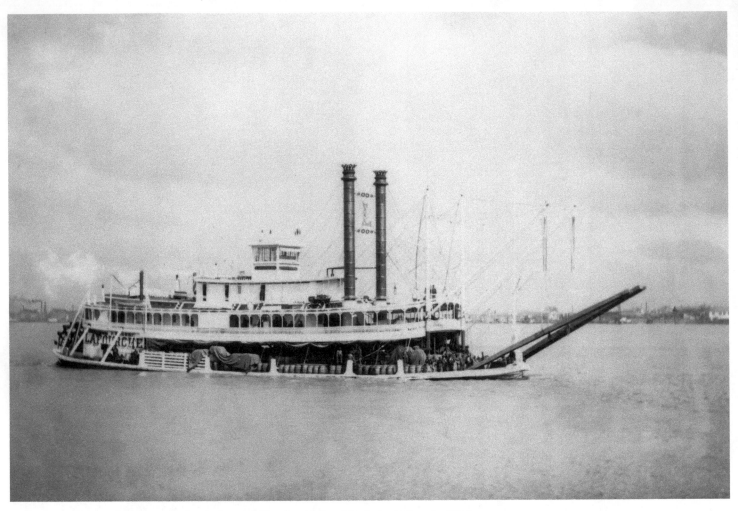

Laden with freight, the stern-wheeler *Lafourche* plies the mighty Mississippi River in 1898.

The Joy of the Golden Age

(1900–1919)

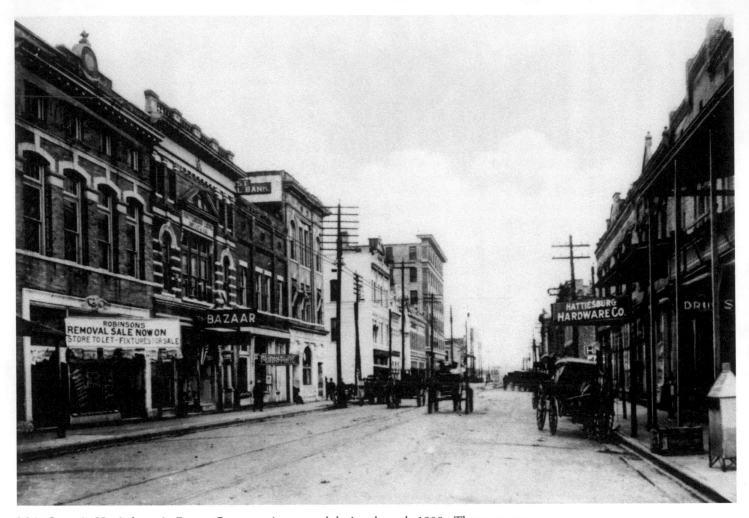

Main Street in Hattiesburg, in Forrest County, as it appeared during the early 1900s. The town was incorporated in 1884 when the Southern Railway system was built from Meridian to New Orleans, passing through the hamlet known originally as Twin Forks and later as Gordonville. Captain William H. Hardy, a local pioneer lumberman, civil engineer, and early settler, contributed the final name of Hattiesburg in honor of his wife, Hattie.

The site of Old Fort Bayou, at Ocean Springs in Jackson County, as it appeared in 1901. Mineral springs were discovered in the 1850s and a sanatorium was built. Ocean Springs was founded as Fort Maurepas by the French in 1699, to discourage the Spanish from encroaching on French territories in the new world.

An early 1900s view of the charming beachside at Bay St. Louis in Hancock County. Locals gaze toward the bay, accessible by a long pier visible in the distance. The town was named for King Louis IX of France.

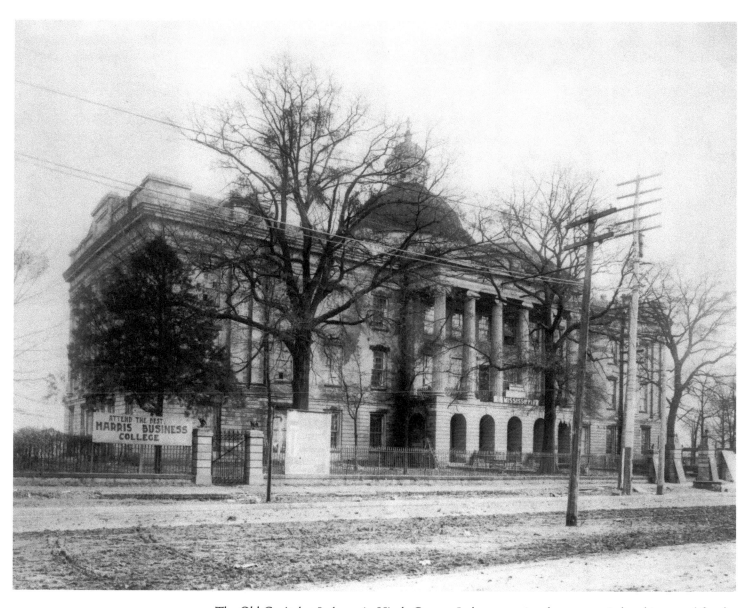

The Old Capitol at Jackson, in Hinds County. Jackson remains the state capital and is named for the seventh president of the United States, Andrew Jackson. The Old Capitol served as the home of the Mississippi state legislature from 1839 to 1903.

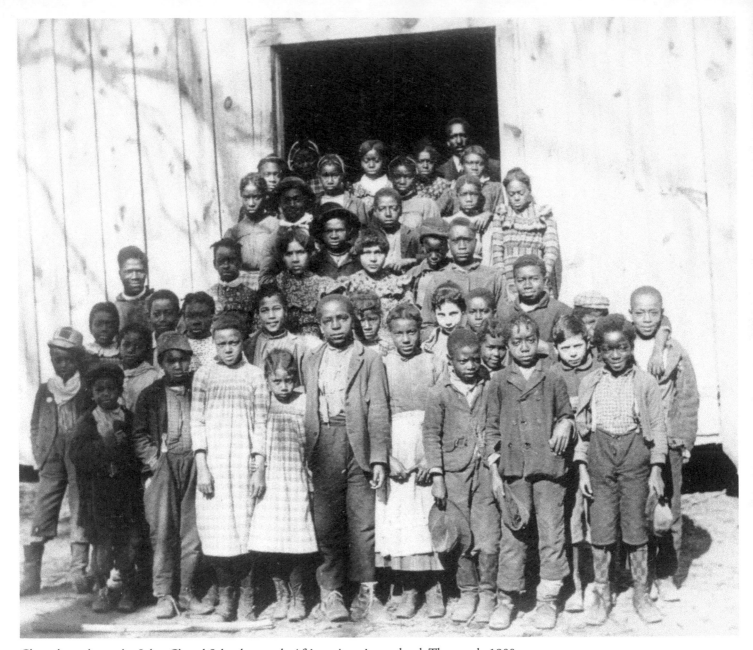

Class photo day at the Sykes Chapel School, an early African-American school. These early 1900s students have filed out of the building for the group portrait.

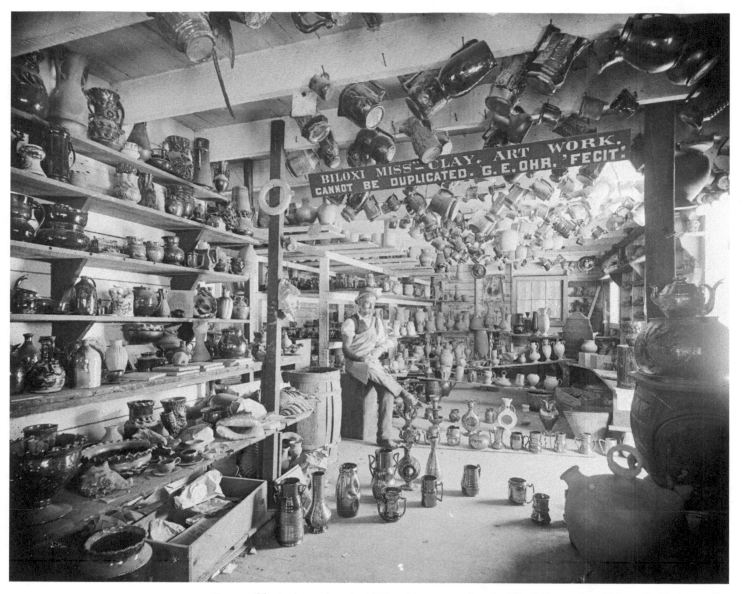

George Ohr is shown here in 1901 at his pottery shop in Biloxi. Examples of his work fill the studio. Ohr's works were one-of-a-kind, as unique as his one-of-a-kind handlebar moustache.

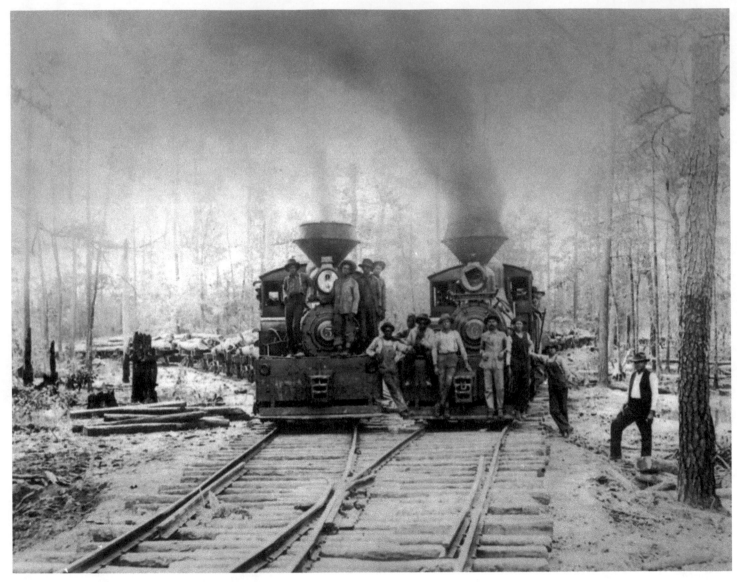

Steam engines pair up in Wayne County to haul pine logs from the forests of east central Mississippi in 1905. The lumber and lumber transport businesses flourished during the late 1800s, as logging became the main industry of the area. These loggers are shown at Robinson Lumber Company.

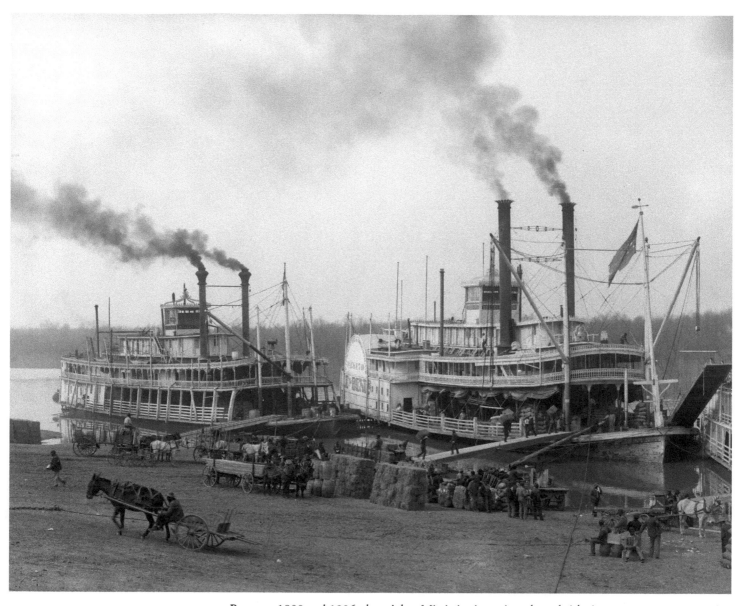

Between 1900 and 1906, the mighty Mississippi continued as a brisk river-transport opportunity. Shown here are the stern-wheeler *Belle of Calhoun* and (at right) the side-wheeler *Belle of the Bends,* of the Vicksburg and Greenville Packet Company.

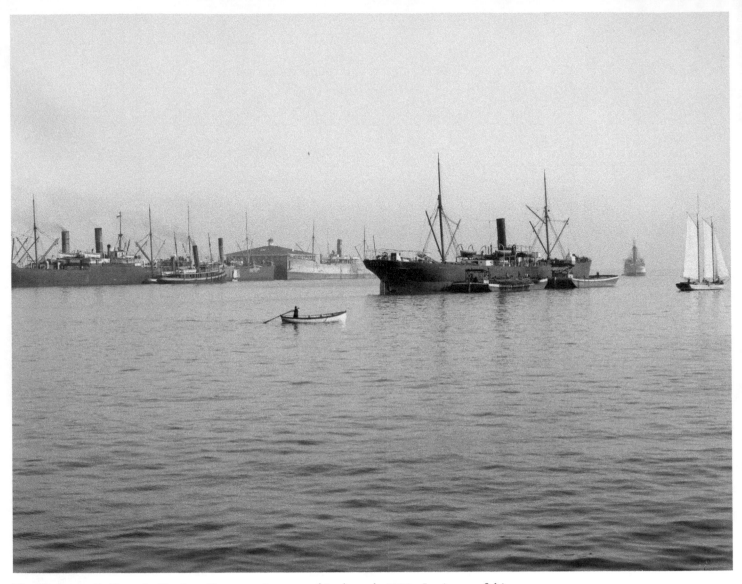

The Harbor at Gulfport, in Harrison County, as it appeared in the early 1900s. In view are fishing boats, sailboats, freightliners, and a boat dock in the distance.

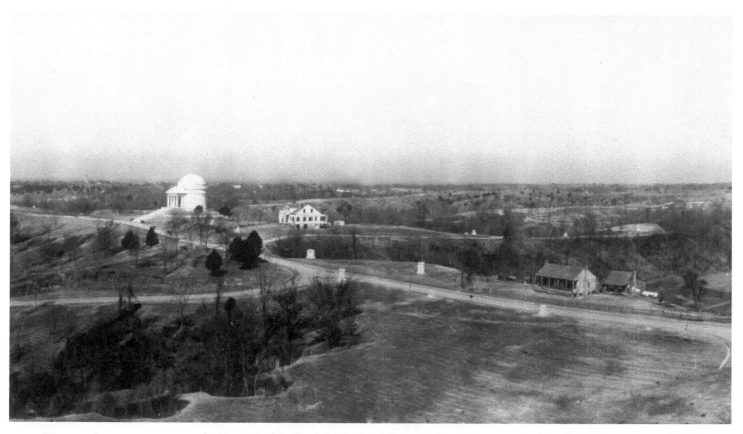

Panorama of the battlefield at Vicksburg, in the early twentieth century. Although the battle and siege lay 50 years in the past, the landscape is still barren. Prominent among the many monuments to fallen heroes is the Illinois State Memorial, the domed structure at left. Modeled on the Roman Pantheon, it was dedicated in 1906. Forty-seven steps lead to it, one step for each day of the Vicksburg siege.

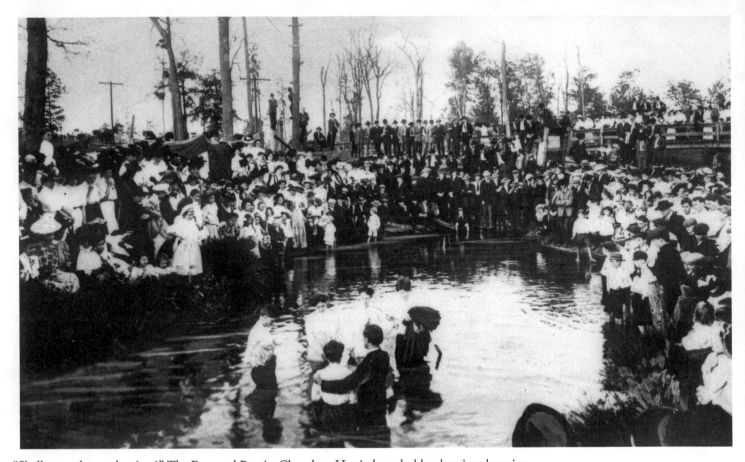

"Shall we gather at the river?" The Emanuel Baptist Church at Hattiesburg holds a baptismal service in 1910, immersing converts in a local body of water.

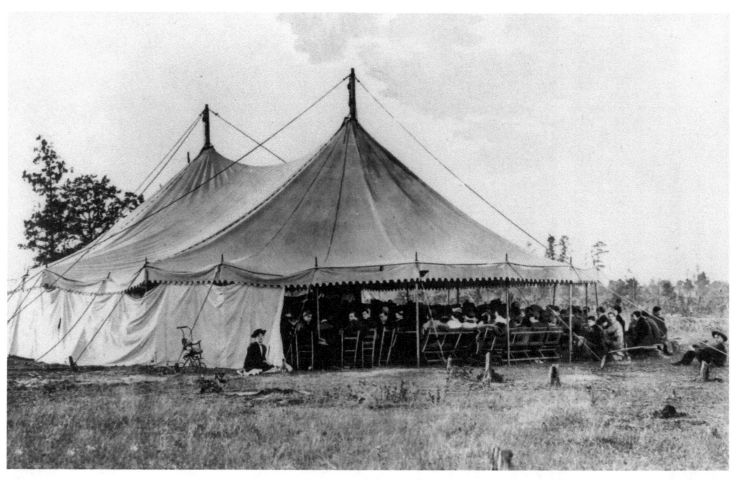

The beginnings of the Emanuel Baptist Church in Hattiesburg. Early churches were often organized following evangelistic revivals held at camp meetings where large tents were filled to capacity.

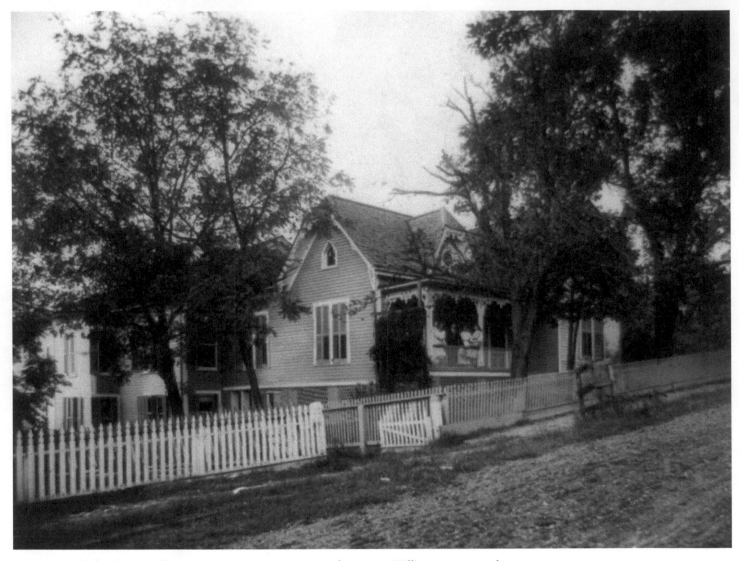

The home of John Sharp Williams, in Yazoo City, as it appeared in 1908. Williams represented Mississippi in the U.S. House of Representatives from 1893 to 1909 and the U.S. Senate from 1911 to 1923.

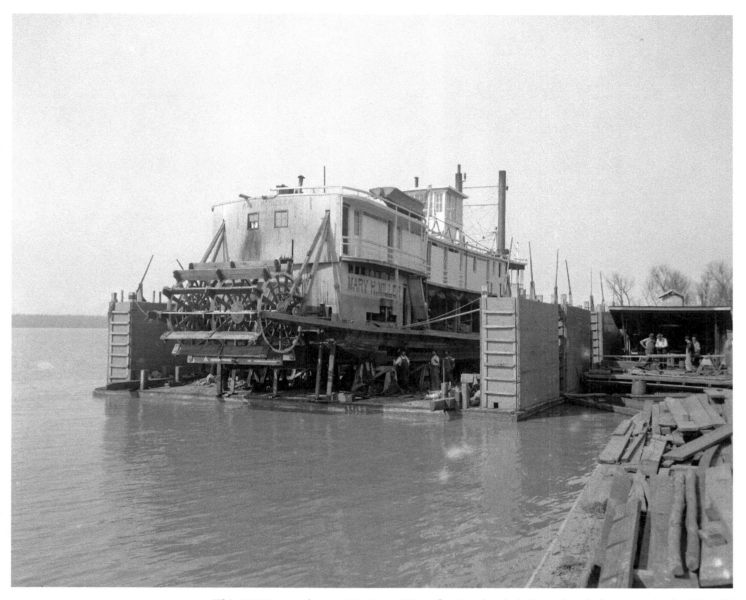

This 1910 image shows a Mississippi River floating dry dock, loaded with the stern-wheeler *Mary H. Miller*, which is undergoing repairs.

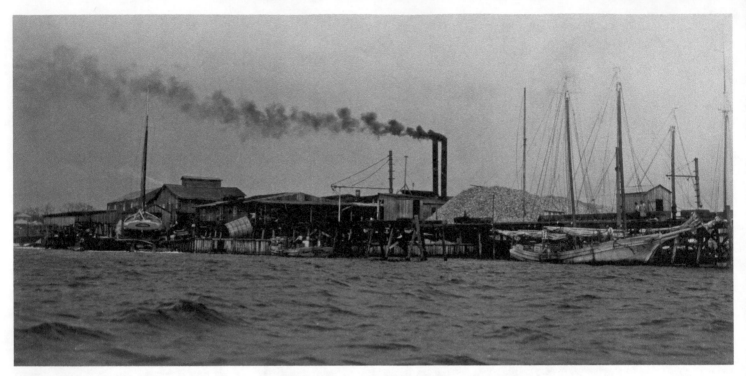

Work is under way in February 1911 at the Pass Packing Company, in the town of Pass Christian. The rippling waters of the Gulf of Mexico are visible in the foreground. Pass Packing Company was a cannery specializing in the shucking and canning of oysters.

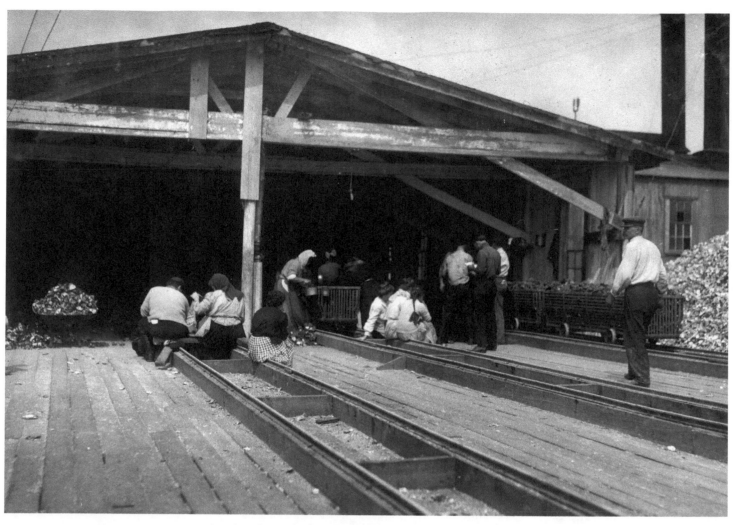

Another day at the Pass Packing Company in February 1911. Discarded oyster shells and a system of tracks and track carts for moving the product from point to point are visible at right.

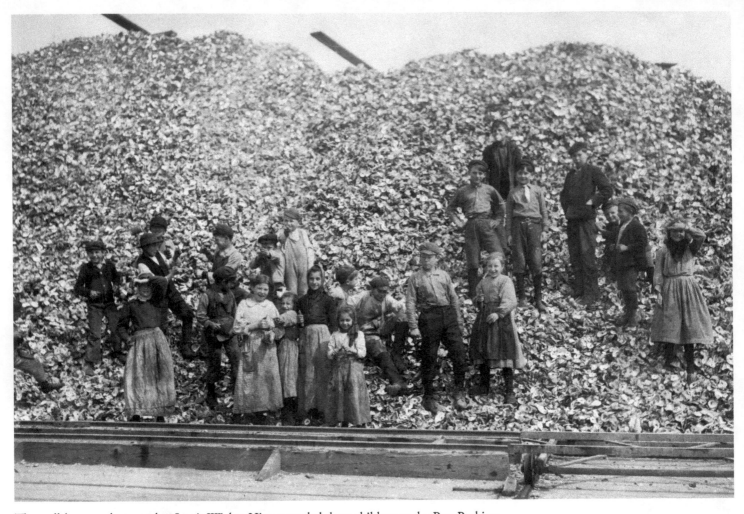

The well-known photographer Lewis Wickes Hine recorded these children at the Pass Packing Company, employed at the cannery as oyster shuckers in 1911. During the 1910s, Hine was a freelance photographer for *The Survey,* a leading social reform magazine, traveling nationwide to document child labor and its effects on the nation's youth. This image and several to follow provide a glimpse of some aspects of Mississippi society during this decade. These particular children are clearly wearing smiles, in spite of their challenging circumstances.

Lewis Hine recorded this image in 1911 at Meridian, titling it *The Dependent Widower*. The sign beneath the store window asks, "Have You Smoked Bagdad?"

Workers break for the noon hour in May 1911 at McComb's Delta Cotton Mills, in Pike County.

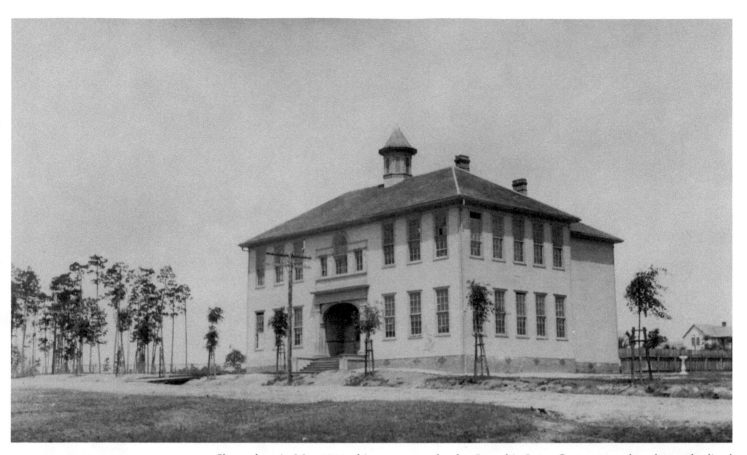

Shown here in May 1911, this two-story school at Laurel in Jones County served students who lived in the mill district. By 1900, 92 percent of textile mill workers lived in mill villages—owned by the companies that employed them—with houses for employees and their families, churches, a school, and the company store.

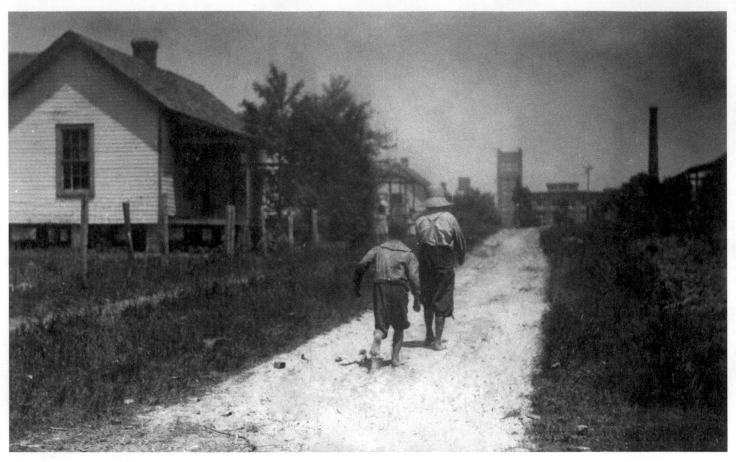

Two barefoot boys in Tupelo scramble up the dirt pathway toward the Cotton Mills company store in May 1911. To the left is a typical house for workers and their families, and in the distance rises the mill tower. Years later, in January 1935, rock 'n' roll legend Elvis Presley would be born in Tupelo.

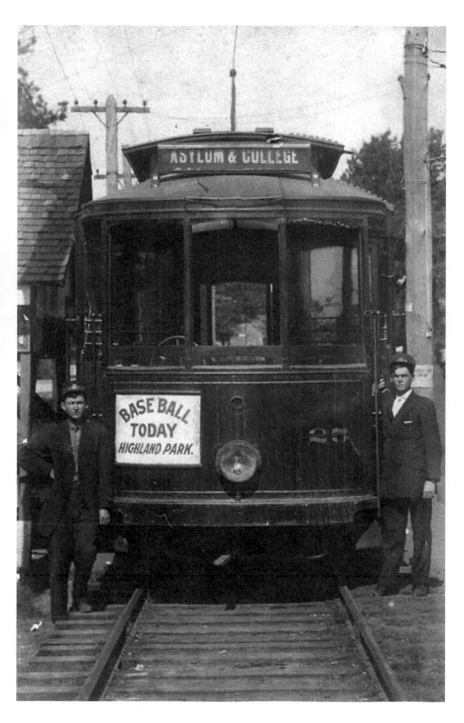

Jack Norworth's 1908 Tin Pan Alley tune "Take Me Out to the Ballgame" was inspired by a trolley sign much like this one in Meridian. The trolley ad announces, "Baseball Today: Highland Park," only a short streetcar ride and minutes away. The only double track running beyond downtown Meridian went to exciting Highland Park.

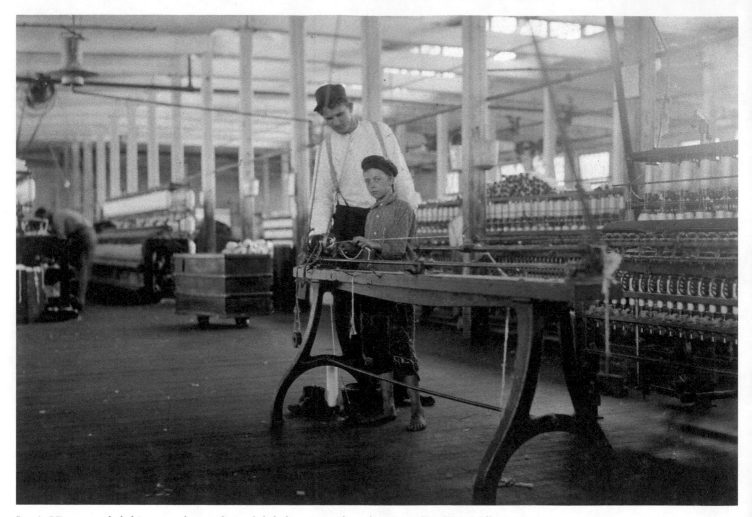

Lewis Hine recorded this young boy and an adult helper at work at the Yazoo City Yarn Mills, in Yazoo County, in May 1911. Yazoo City was founded in 1824 and burned twice—once when it was torched by Union forces during the Civil War, and accidentally in 1904 by a youngster playing with matches. The motivational speaker Zig Ziglar and Mississippi governor Haley Barbour both grew up in Yazoo City.

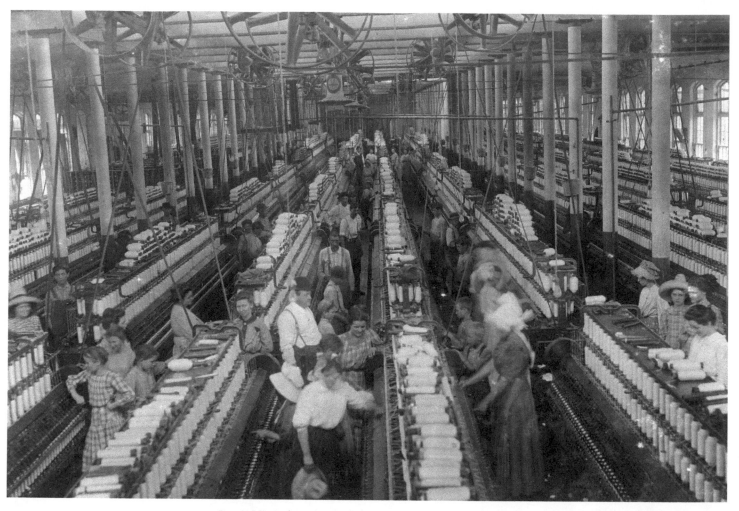

Lewis Hine photographed these workers, some of them children, inside the Magnolia Cotton Mills spinning room. Magnolia, in Pike County, was founded in 1856 by cotton planter Ansel Prewett, who hoped to take advantage of the approaching railroad then under construction. While serving as sheriff in the 1870s and escorting a prisoner along the same railroad, Prewett was killed by outlaws. The town itself would prosper as a popular destination for vacationing New Orleaneans.

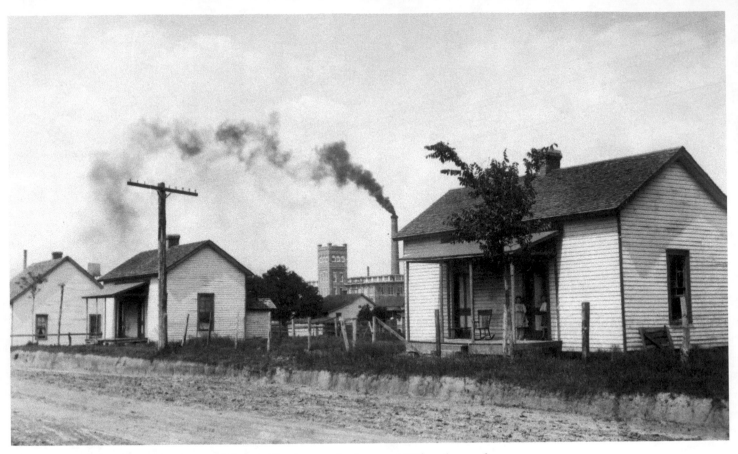

Lewis Hine noted in May 1911 that conditions in Tupelo were "rather good." Three houses for workers stand side by side, with the mill visible in the background. Known as Gum Pond before the Civil War and a battle that took place here, Tupelo is situated in the northeastern part of the state. A year before Elvis was born, Tupelo became the first city to get electric power through the newly created Tennessee Valley Authority.

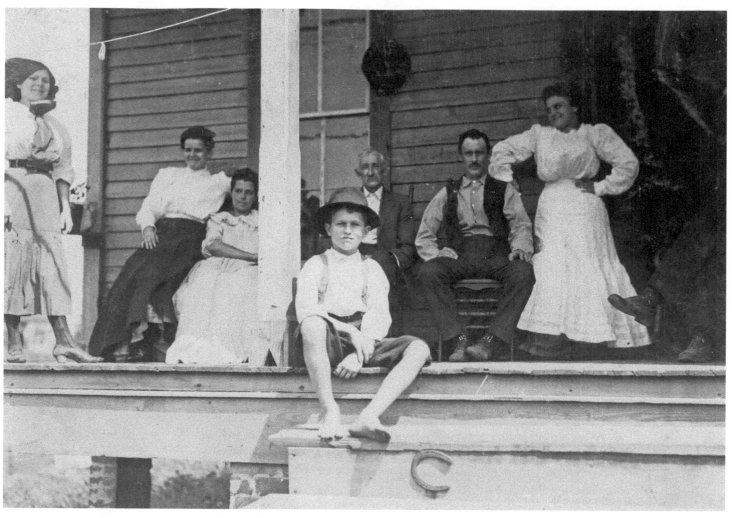

This mill family enjoys the front porch of their company-owned house in Magnolia, and they seem rather content, well fed, and nicely dressed. Hine indicates that all family members worked at the mill, including 13-year-old Wilbert Bennett, sitting on the porch steps.

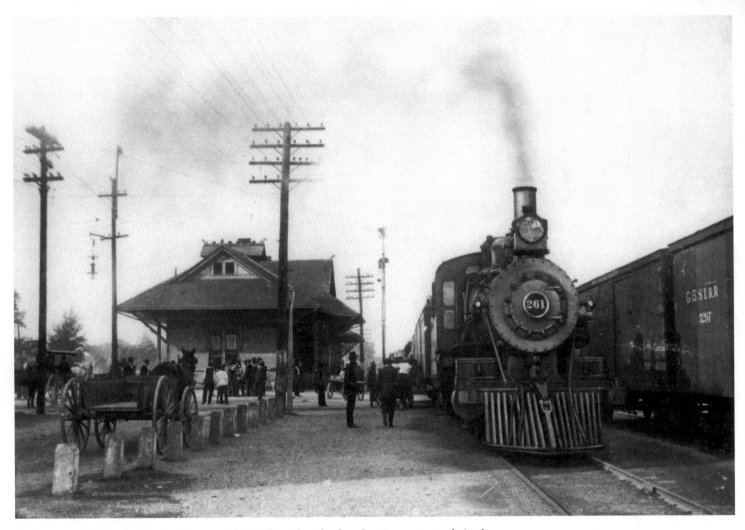

Engine no. 261 idles beside the depot at Biloxi. The railroads played an important role in the economic development of the entire state of Mississippi.

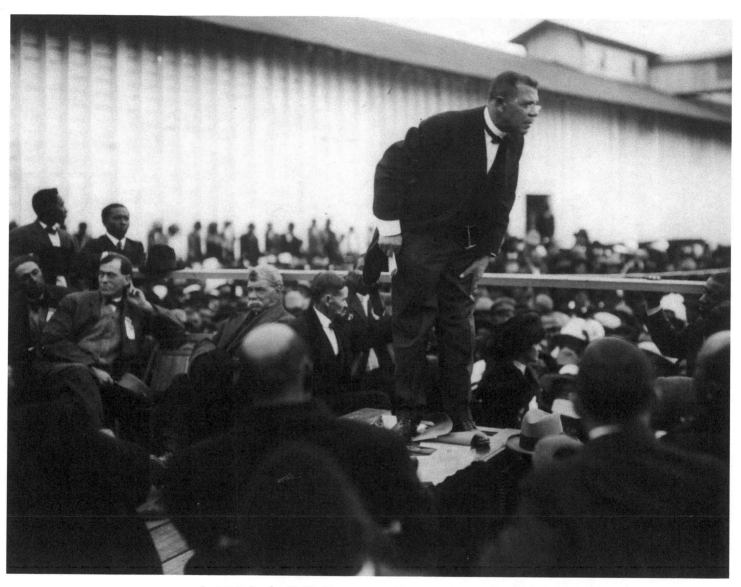

In 1912, Booker T. Washington, an educator, orator, author, and black leader, spoke at Mound Bayou, in Bolivar County, noteworthy for being founded by former slaves. The photograph suggests that Washington's speech was passionate and the audience attentive.

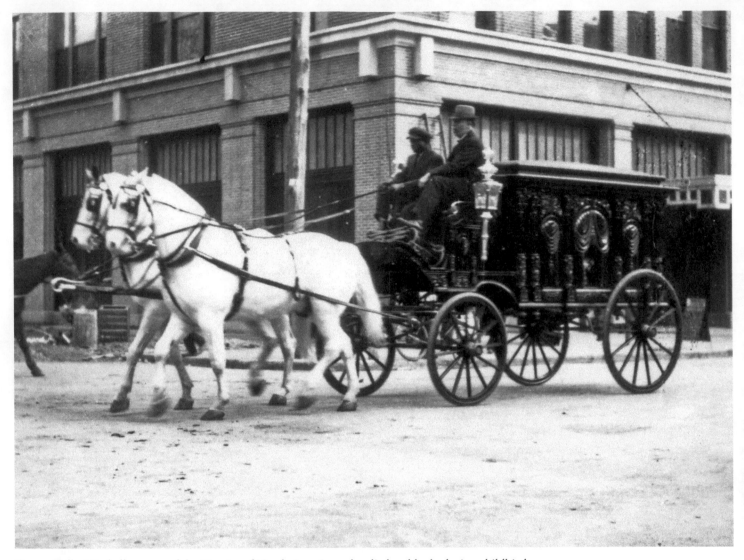

Queen Kelly Mitchell, queen of the Gypsies of North America, who died suddenly during childbirth, is laid to rest in February 1915, her funeral hearse drawn by a team of white horses. An estimated 20,000 people from all over America attended the funeral. The mahogany, glass-covered casket was taken to lovely Rose Hill Cemetery in Meridian. King Emil would later be buried next to his wife.

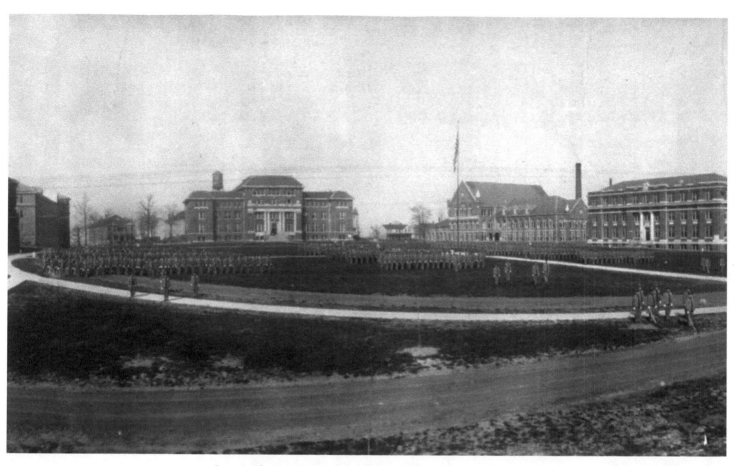

On March 15, 1914, at Mississippi A&M College, a regimental parade is in progress. The university began as the Agricultural and Mechanical College of the State of Mississippi, a land-grant institution made possible by the Morrill Act of 1862. In 1958, the university was renamed Mississippi State University.

This three-story public school at Pass Christian was photographed in February 1916.

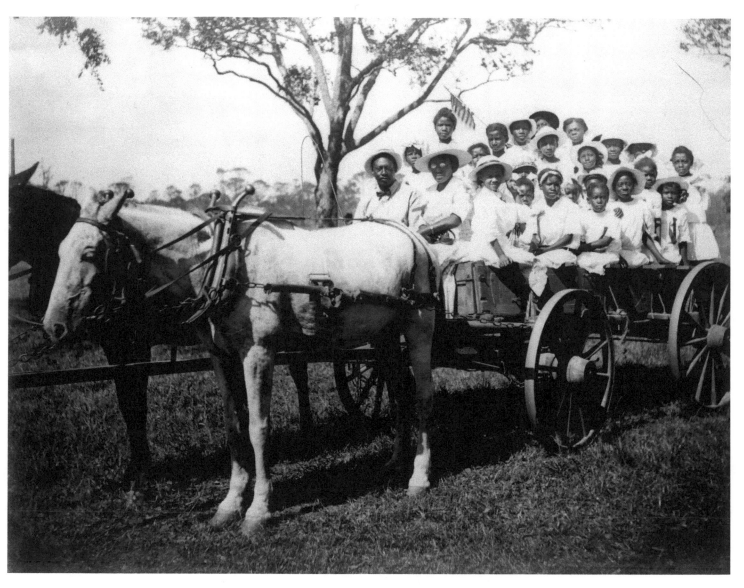

This patriotic group enjoys a Sunday afternoon outing in 1916, stopping their horse-drawn wagon to pose for a photograph. The couple at front and 22 youth all dressed in white suggests that they were members of a church class.

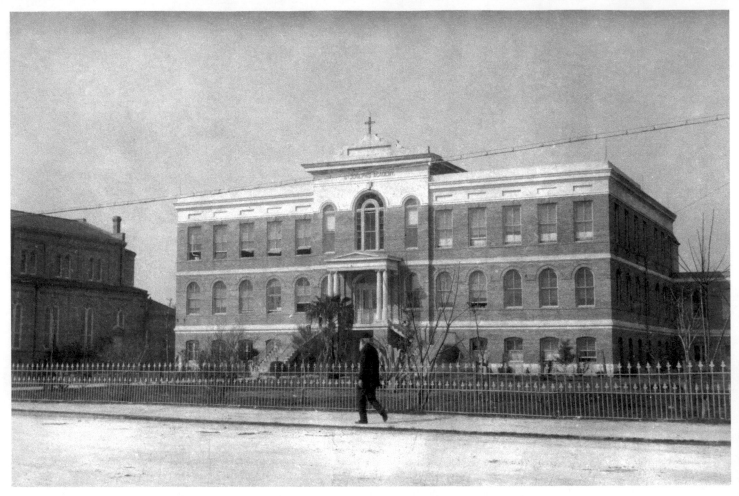

A pedestrian passes the impressive St. Joseph's Academy school for girls, at Bay St. Louis in Hancock County, in February 1916. The building was damaged in the great fire of November 16, 1907, but appears fully restored in this image. In 1965, the damage wrought by Hurricane Betsy would lead to the school's closing, and still later Hurricane Katrina would badly damage Our Lady Academy, the all-girls school that replaced it.

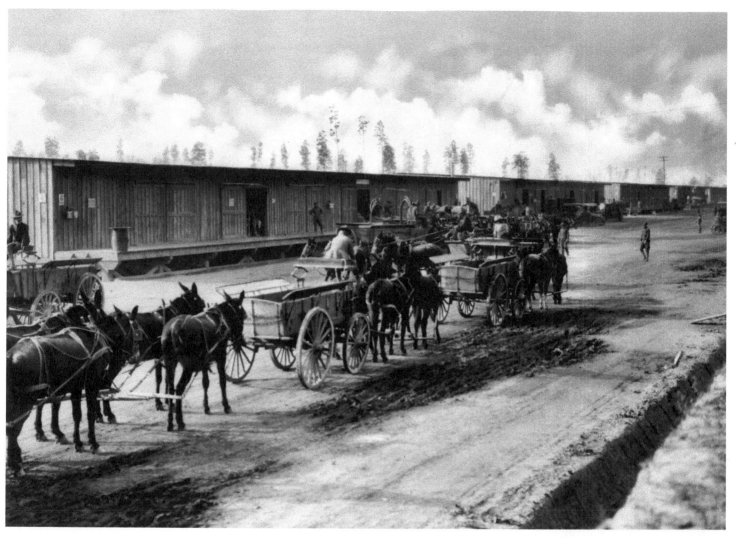

Warehouses with mules and spring wagons are shown at Camp Shelby military base in Hattiesburg in 1918. The military post was established in 1917 as part of the buildup for World War I.

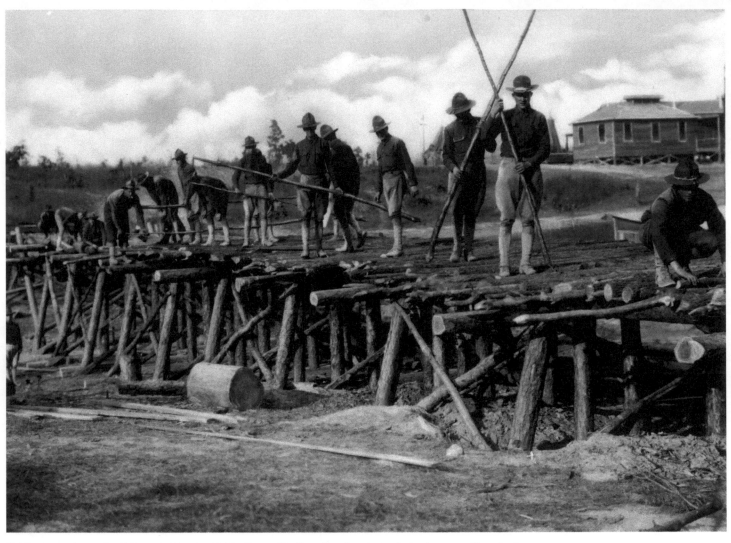

Soldiers are shown building a bridge in 1918. Camp Shelby played a vital role in the war effort during World War I.

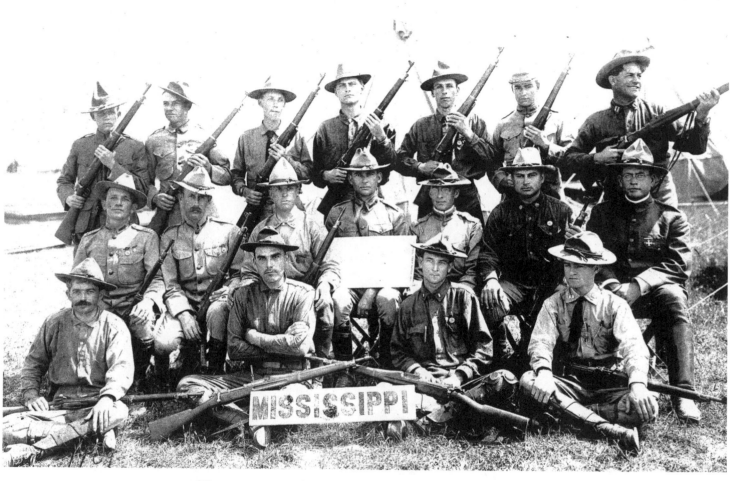

These young men, disciplined and courageous, are members of the World War I Mississippi Riflemen, known as Mississippi's oldest National Guard unit and the seventh-oldest infantry regiment in the United States Army. Its history predates statehood, back to June 1799. The unit accompanied General Pershing on the Mexican Expedition against Pancho Villa in 1916. During World War I, the unit was designated the 155th Infantry Regiment and fought with the 30th Division, and during World War II, they fought in the Pacific theater.

Built by local craftsmen in 1857, Stanton Hall at Natchez, in Adams County, remains one of America's largest antebellum mansions. Noted photographer Frances Benjamin Johnston recorded this image in the 1920s. In 1932, the Natchez Pilgrimage, an annual tour of the area's antebellum homes, would become a popular event that continues today.

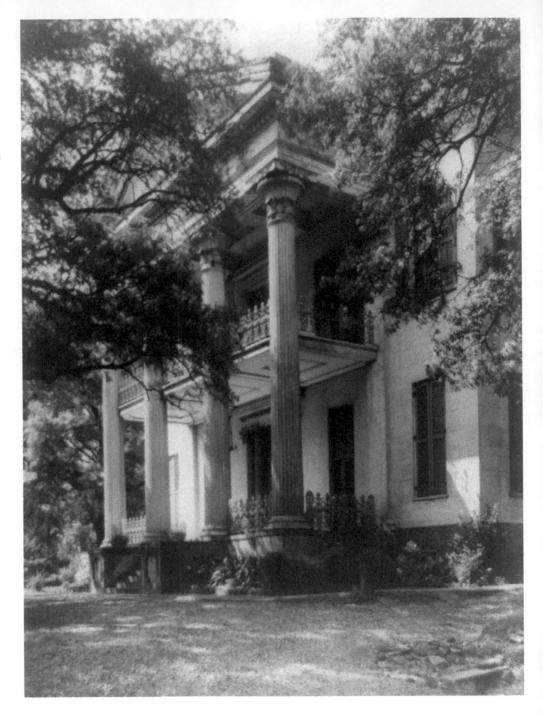

Depression Years and Singing the Blues

(1920–1939)

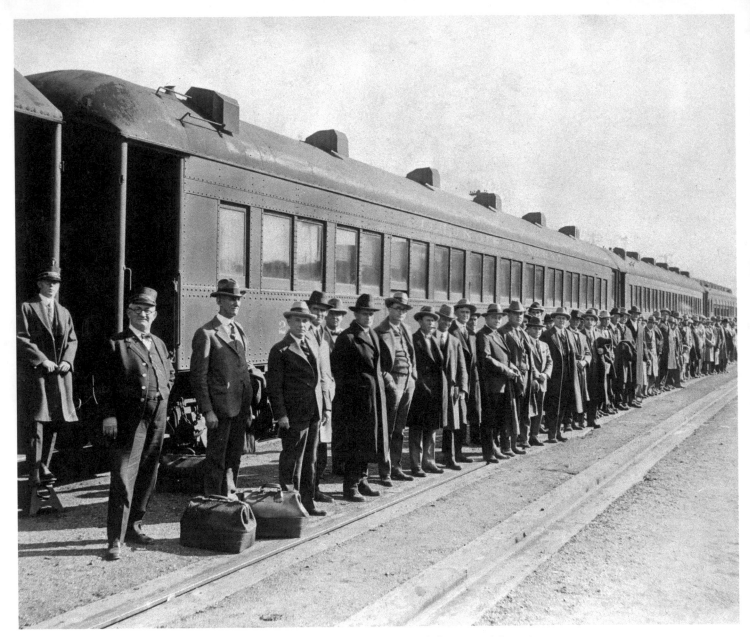

A special train idles at the depot at McComb, in Pike County, sometime around the 1920s. The train, sponsored by the McComb chamber of commerce, was carrying farmers and businessmen to the state agricultural college located at Starkville, to promote dairy development for Pike County.

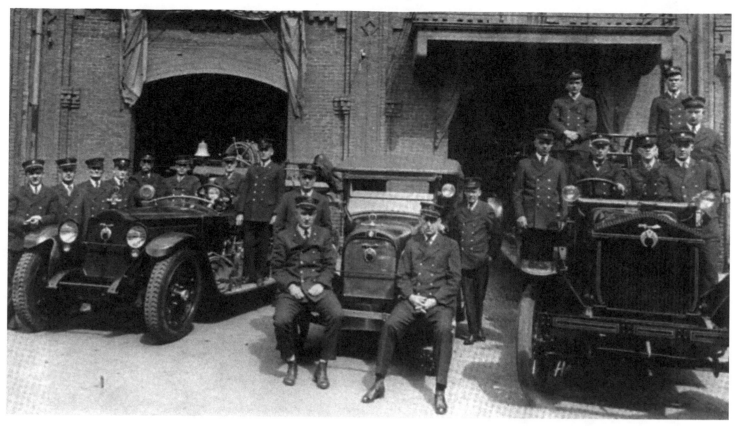

Between 1890 and 1930, Meridian was the largest city in Mississippi. Shown here is the Meridian fire department, smartly dressed with equipment gleaming, assembled for a group shot in 1920.

The Grand Opera House at Meridian originally opened in 1890. It was remodeled in 1902 and again in 1920, when it was converted in part to a movie theater. The lovely theater would succumb to neglect after 1927, but survived intact through the 1960s sheathed in metal siding. Today it stands restored to its original luster as the MSU Riley Center.

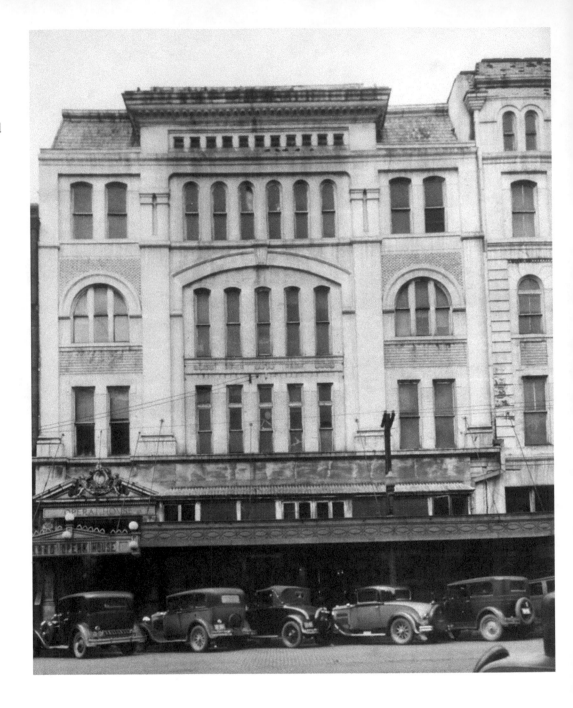

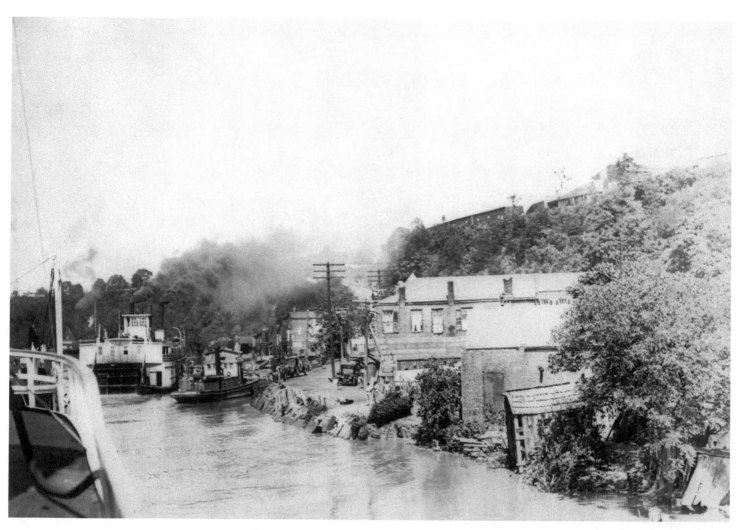

In 1927, the Mississippi River and tributaries flooded seven states, causing millions of dollars in damage, leaving thousands homeless, and killing hundreds of citizens. This image of the high waters was recorded at a ferry landing in Natchez.

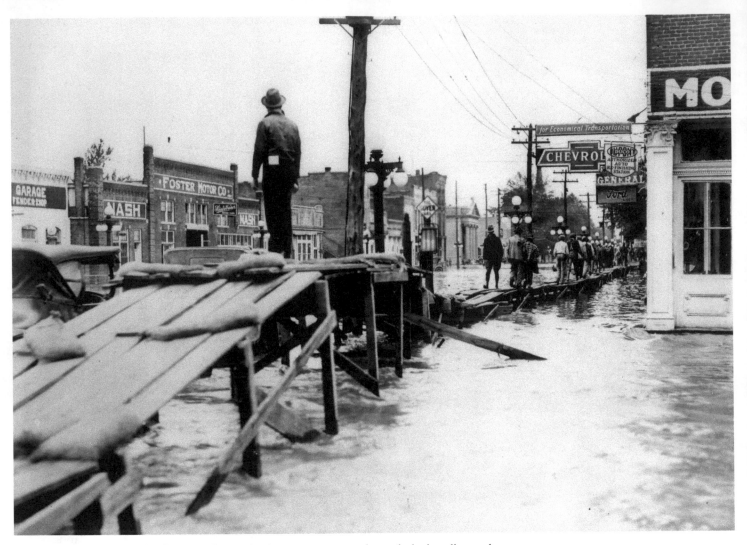

Citizens of Greenville make their way down a business street on an elevated plank walkway above floodwaters that have inundated businesses.

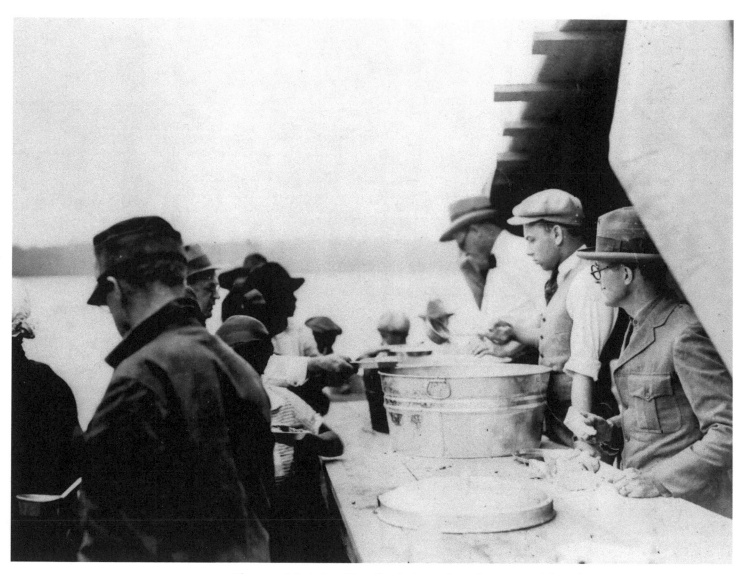

The great Mississippi River flood of 1927 brought everyday life in the Mississippi Delta to a halt. Shown here are refugees in a food line on the levee as food is dispensed.

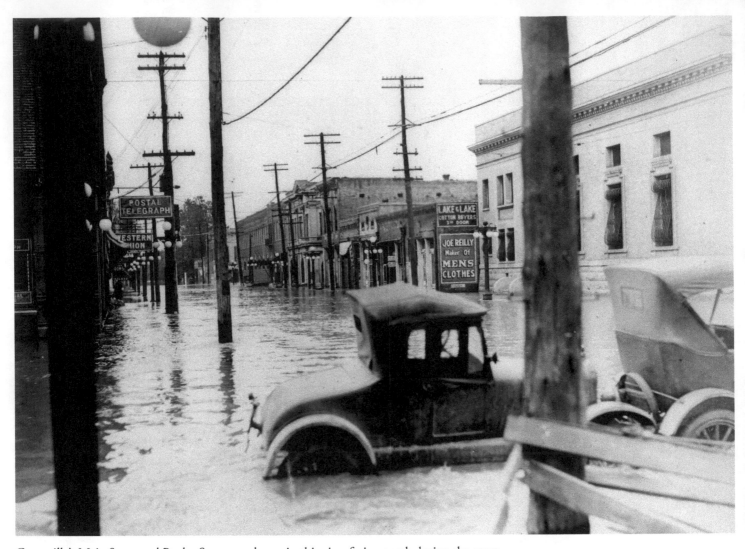

Greenville's Main Street and Poplar Street are shown in this view facing north during the great Mississippi River flood of 1927.

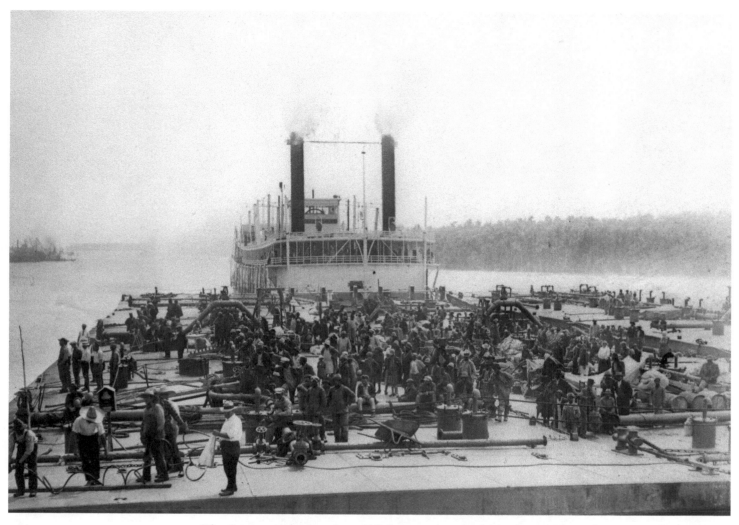

The *Sprague,* at the time the world's largest stern-wheeler towboat, is shown here on April 26, 1927, as it delivers more than 1,300 flood refugees to Vicksburg.

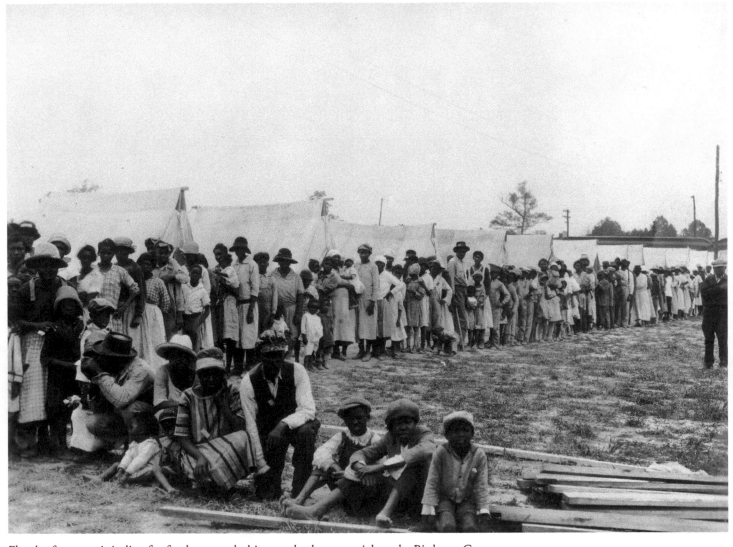

Flood refugees wait in line for food, water, clothing, and other essentials at the Birdsong Camp at Cleveland, in Bolivar County.

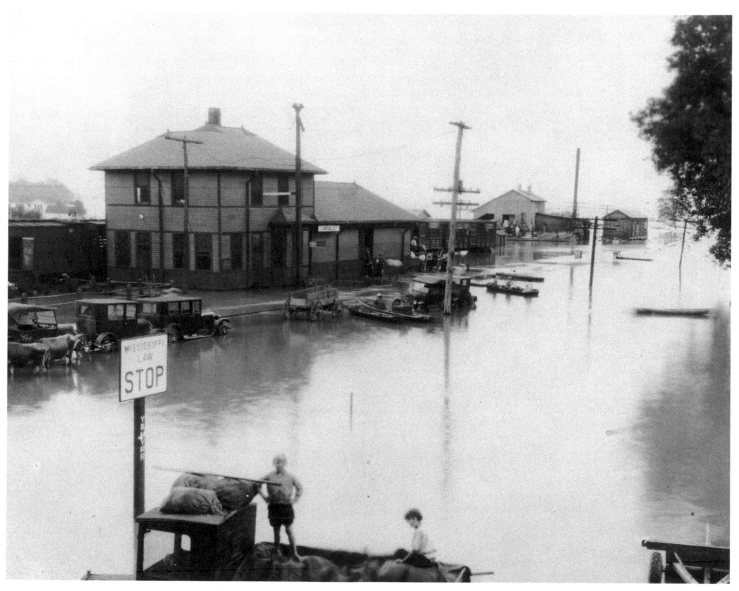

This image shows the flooding at the Yazoo and Mississippi Valley Railroad depot at Anguilla, in Sharkey County.

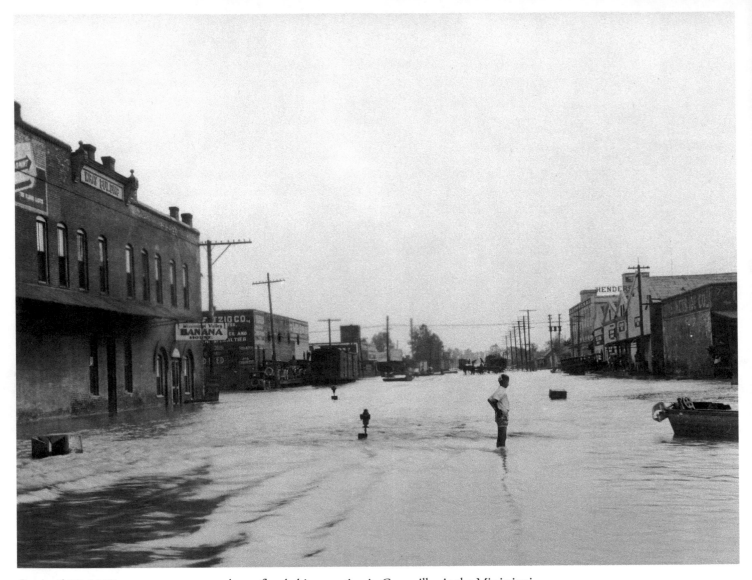

On April 30, 1927, one young man stands at a flooded intersection in Greenville. At the Mississippi Banana House on the left, where bananas are advertised at 30 cents a dozen, business is anything but brisk.

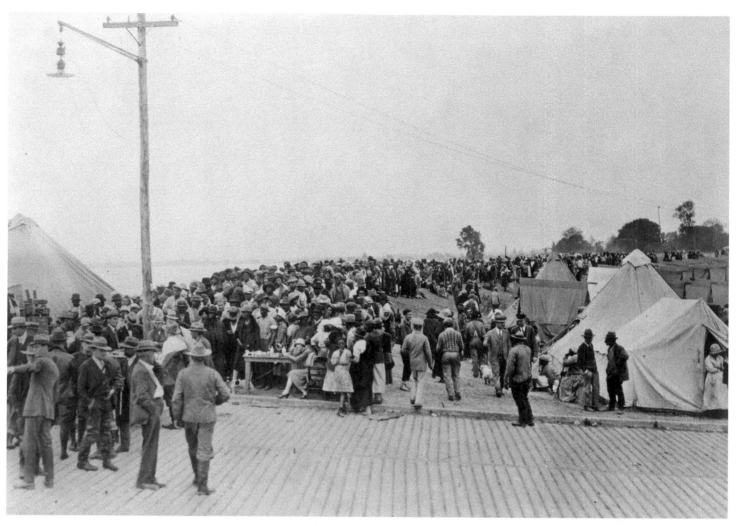

A large crowd has gathered in Greenville as the American Red Cross administers vaccinations during the flood of 1927.

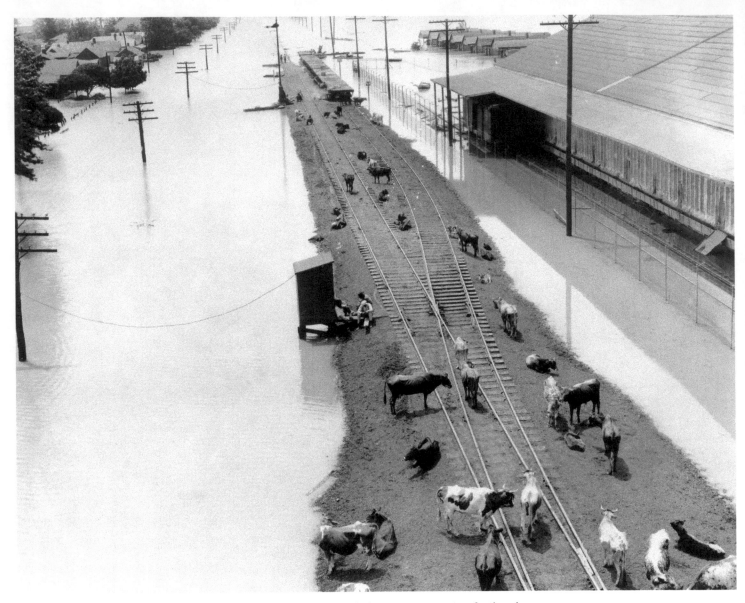

At Leland on April 30, 1927, citizens and livestock alike are stranded on a narrow strip of railroad track.

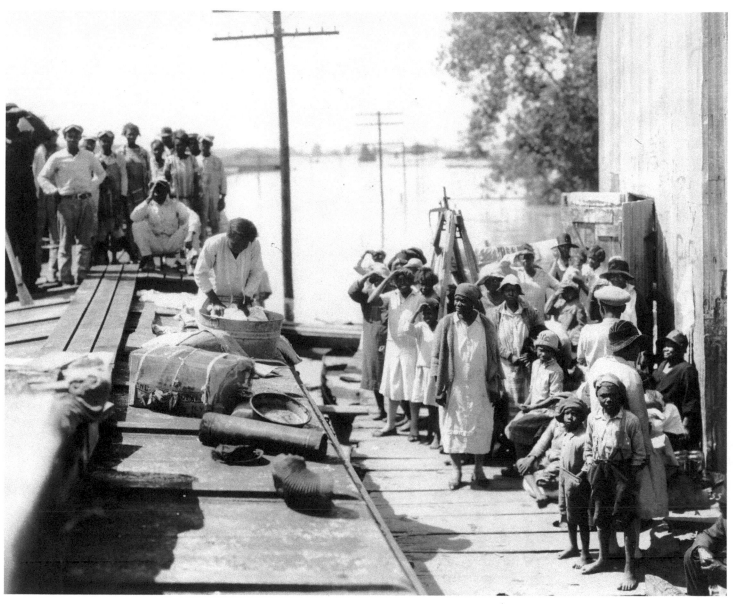

In Rolling Fork, on May 2, 1927, Mississippians affected by the flood stand on railcars and a loading dock, some of them observing one dauntless individual as she scrubs linens on a washboard.

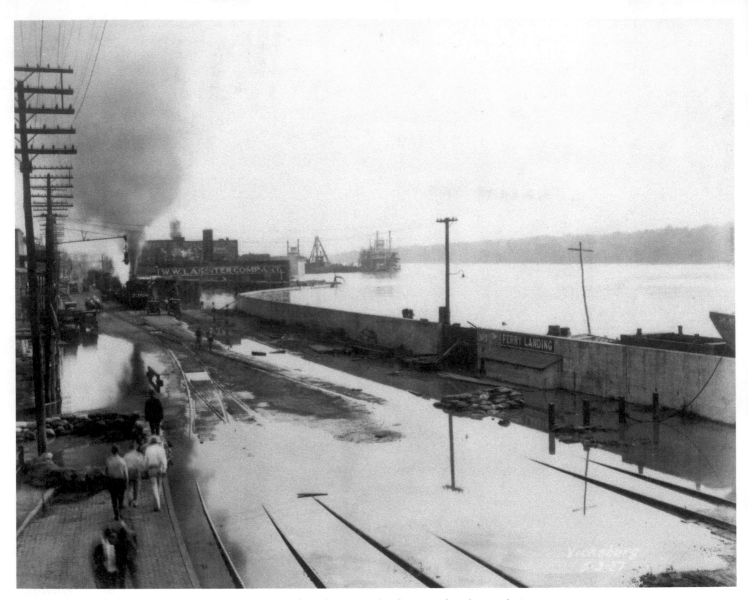

At Vicksburg along the Mississippi River, a riverside rail yard seems to be threatened with inundation should retaining walls crack.

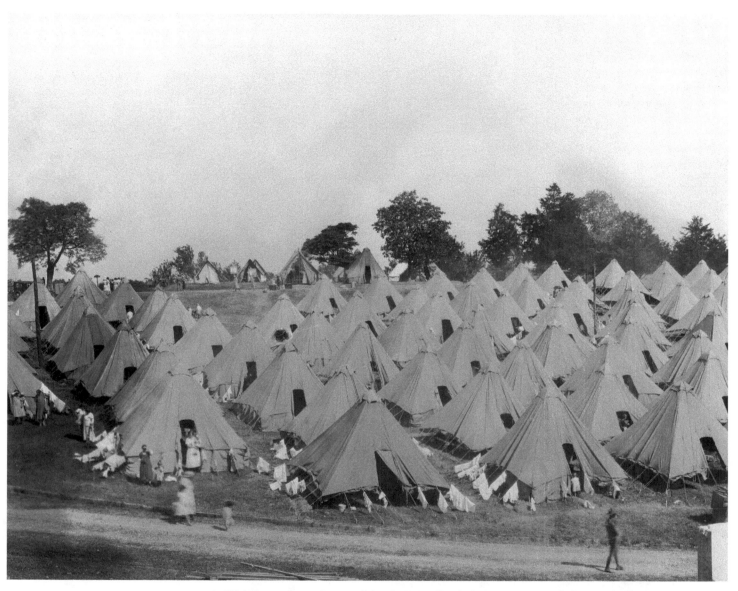

At Vicksburg, shown here on May 3, 1927, flood victims were resettled temporarily in a tent city, on or near the grounds of the national military park. A cannon and historical marker are visible along the treeline. Life goes on as refugees make use of tent ropes to dry laundry. With neighbor helping neighbor, the survival spirit of Mississippians was on full display in trying times.

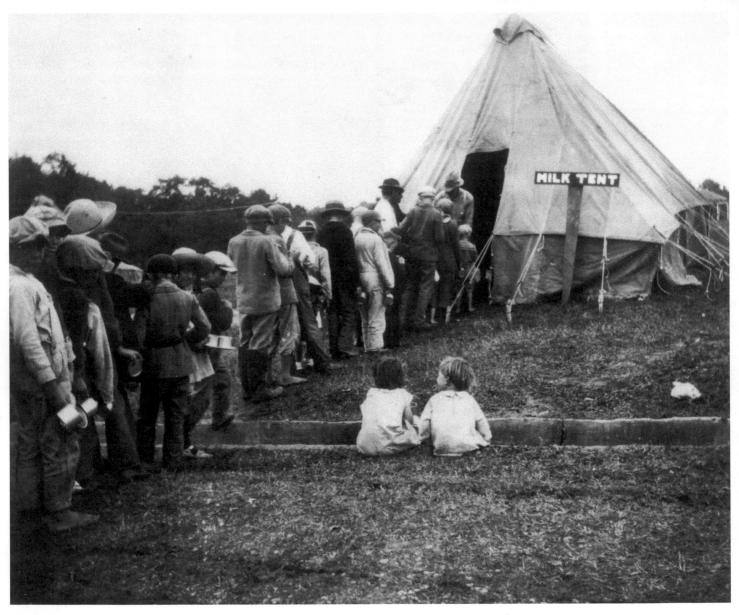

Children at the tent city in Vicksburg wait in line for milk in front of a survival tent during the flood of 1927.

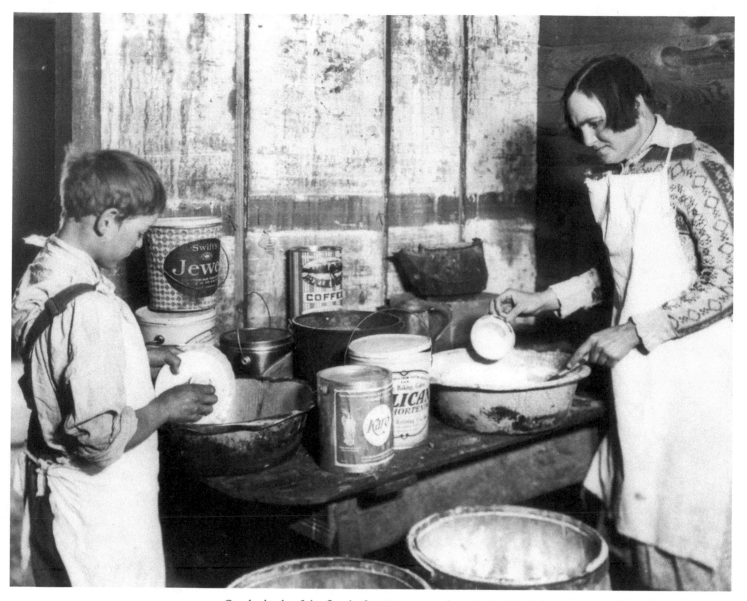

On the heels of the flood of 1927, a severe drought dealt Mississippians trouble in the early 1930s. The family of a tenant farmer works in their kitchen with disaster-relief food supplies provided by the Red Cross.

Mississippi schoolchildren at the Duncan consolidated country school eat lunches provided by the Red Cross during the drought of 1931.

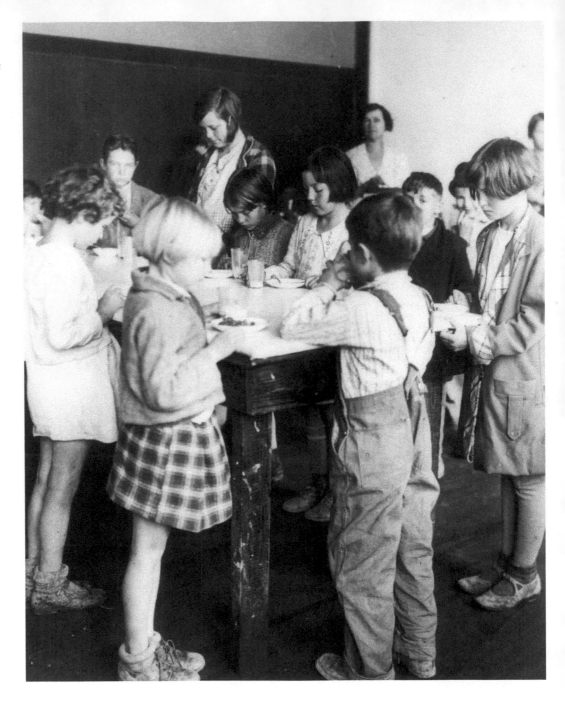

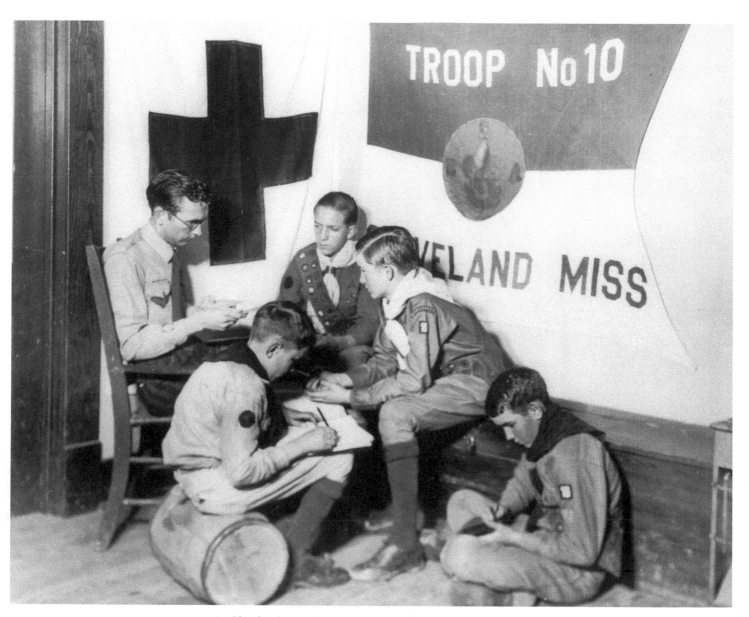

At Cleveland, in Bolivar County, Boy Scouts and their scoutmaster contribute valuable service to the Red Cross drought relief.

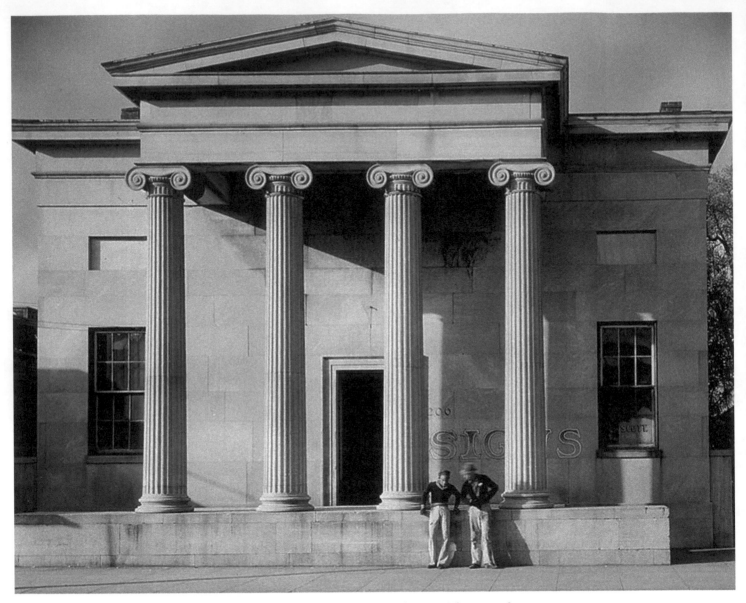

One of the outstanding historic buildings of Natchez is shown here in March 1935. The state of Mississippi proudly claims Natchez, founded in 1716, as one of its oldest cities. Natchez is the southern terminus of the Natchez Trace Parkway, which follows the original trace that linked Natchez to Nashville. Before the Civil War, Natchez boasted more millionaires per capita than any other city in the United States.

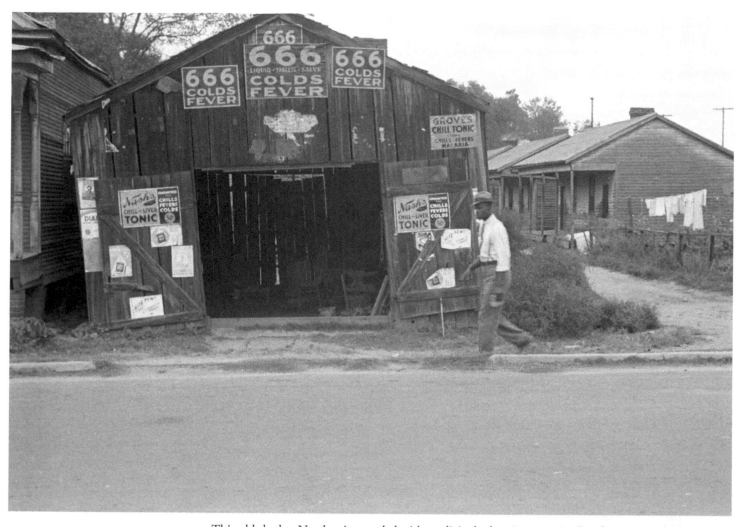

This old shed at Natchez is crowded with medicinal advertisements in October 1935, which tout the wonders of popular remedies of the day. One of them, Grove's Chill Tonic, claims that it "stops chills - fevers - malaria." The cold remedy 666 was widely relied on by cold sufferers and is still manufactured and marketed today.

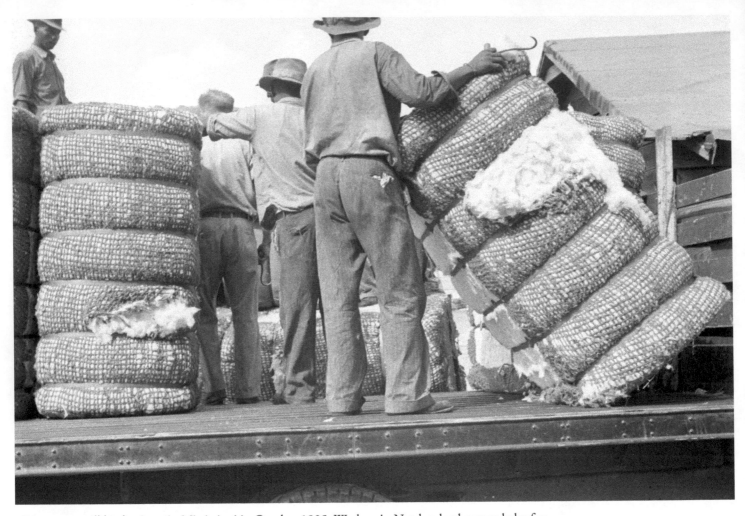

Cotton was still big business in Mississippi in October 1935. Workers in Natchez load cotton bales for export.

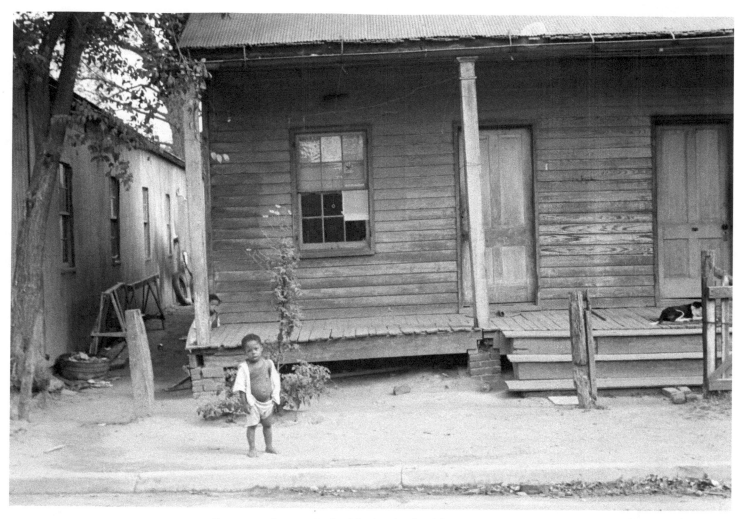

From mansions to shacks, Natchez has been home to a diverse array of citizens. These children stand in front of a badly run-down house in 1935 as a black-and-white pup naps on the front porch. The Great Depression was peaking, leaving many Americans on very hard times.

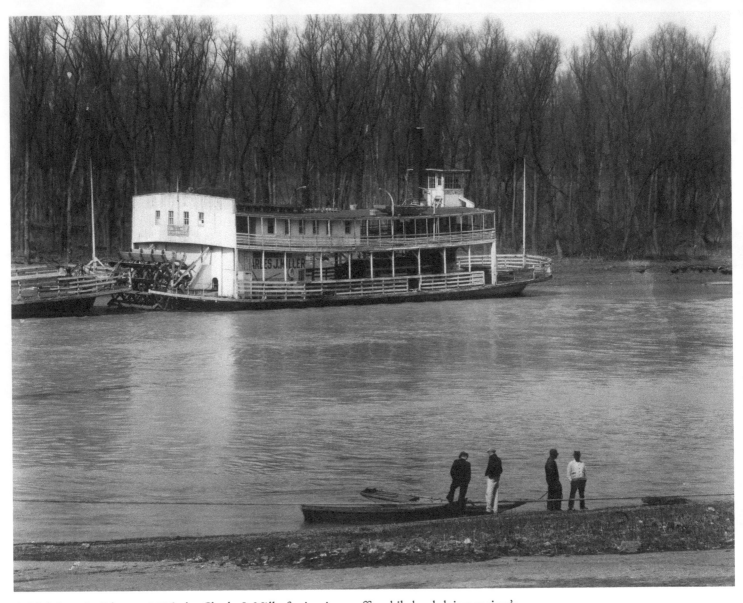

At Vicksburg in February 1936, the *Charles J. Miller* ferries river traffic while locals loiter at river's edge.

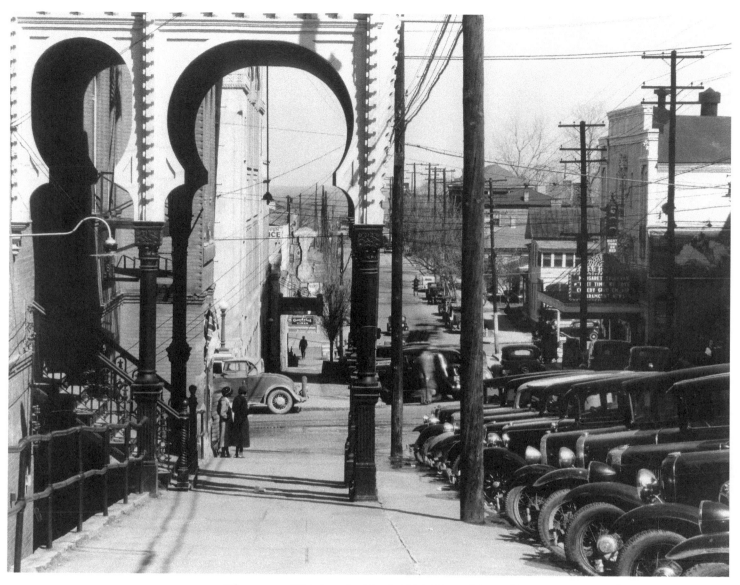

The scene at Vicksburg in March 1936. Most of the parking spaces seem to be taken as two ladies stand at the corner waiting to cross the busy street. In the distance a theater marquee advertises *Next Time We Love,* starring Margaret Sullavan and James Stewart.

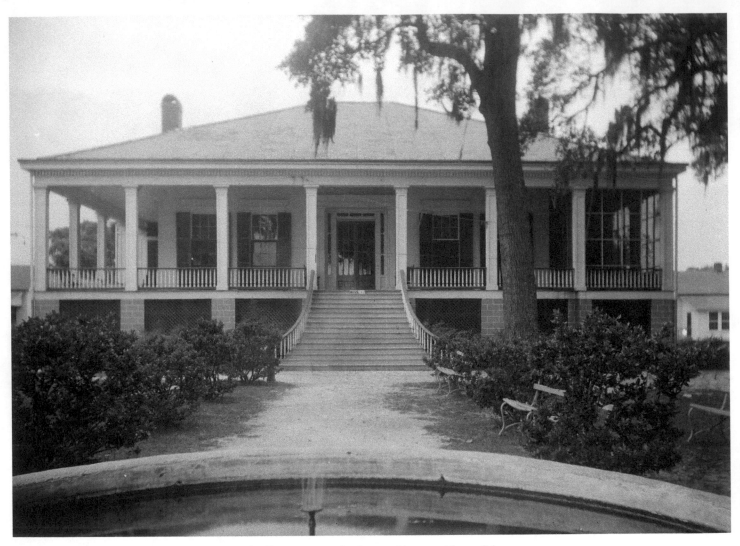

Beauvoir was the beautiful retirement home of Jefferson Davis, the first and last president of the Confederate States of America. Located in Biloxi, the home sits on the north side of Highway 90 and faces the Gulf of Mexico. The historic home is shown here as it appeared on April 22, 1936.

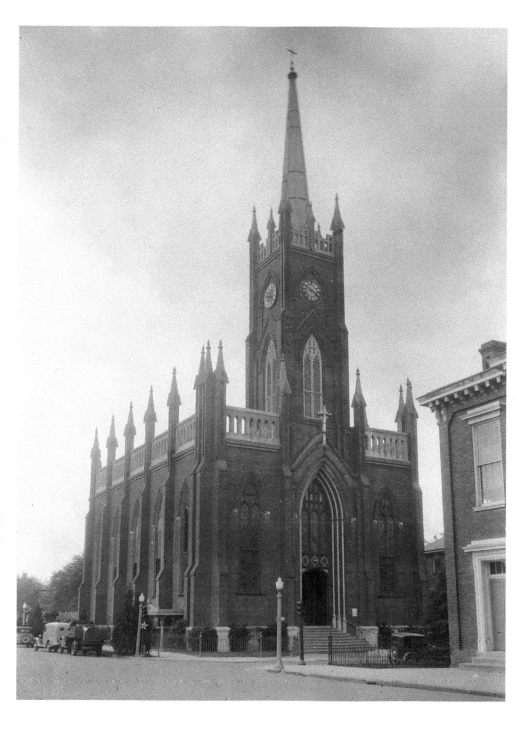

The lovely St. Mary's Cathedral in Natchez as it appeared March 28, 1936. The cathedral's cornerstone was laid February 24, 1842, and the church was dedicated on December 25, 1843. Consecrated on September 19, 1886, it remained the Cathedral of the Diocese until 1977.

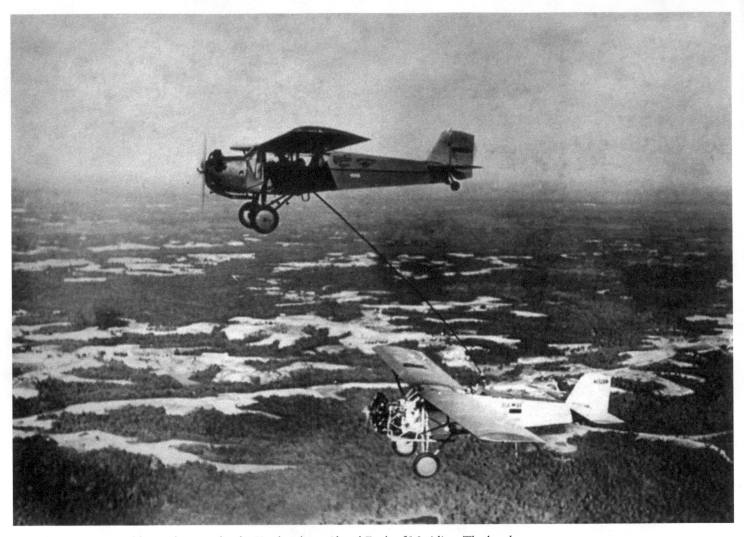

On July 1, 1935, a world record was set by the Key brothers, Al and Fred, of Meridian. The brothers perfected a daring mid-air refueling technique, shown in progress here, that enabled them to keep the *Ole Miss* in flight for more than 27 days. The aviation pioneers captured the attention of the entire world with this accomplishment.

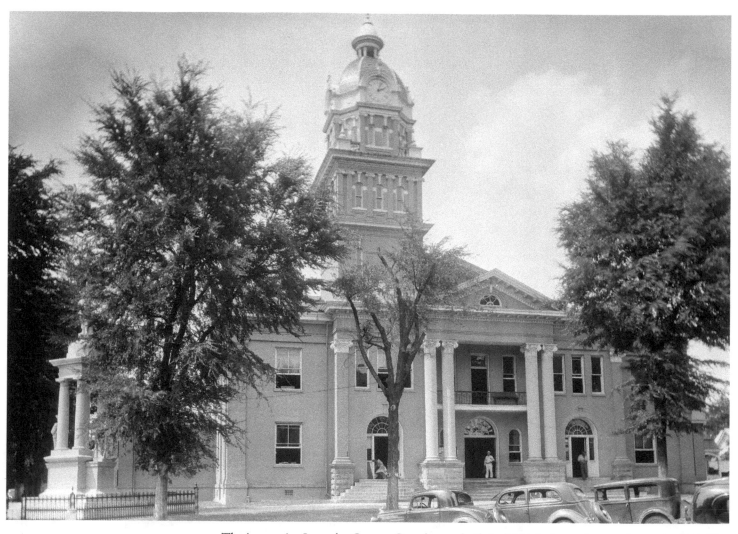

The impressive Lowndes County Courthouse, built in 1847, is shown here on June 10, 1936. The courthouse is located at Columbus, the county seat.

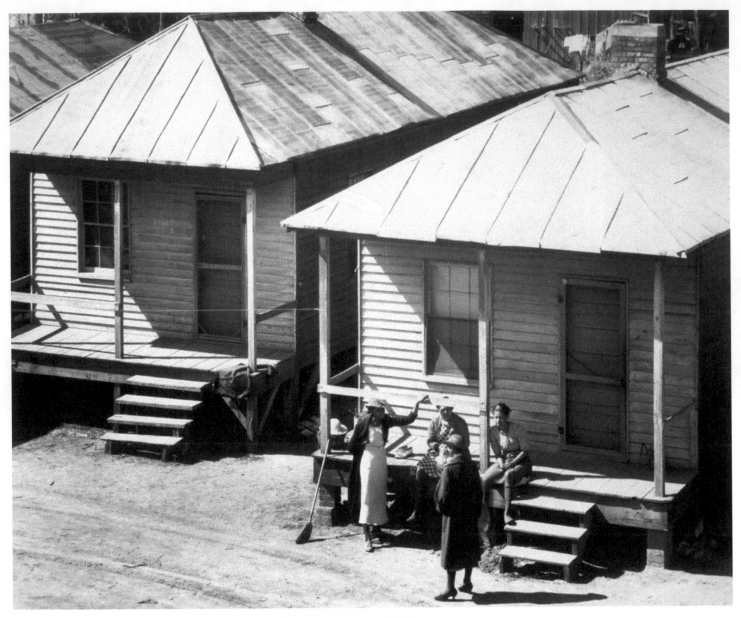

Neighbors gather to swap the local news in this small community in 1936 Vicksburg.

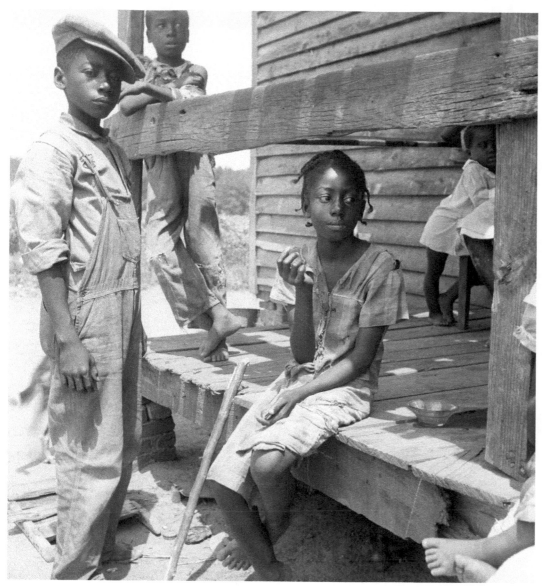

Children of sharecroppers gather porchside on a hot afternoon in July 1936, their routine probably interrupted by the photographer's visit. The rich bottomlands of the Mississippi Delta were suited to row crops, a field of which is just visible in the background at left. The lives of sharecroppers were never prosperous, and the expressions worn by these children suggest that life during the height of the Great Depression was particularly challenging.

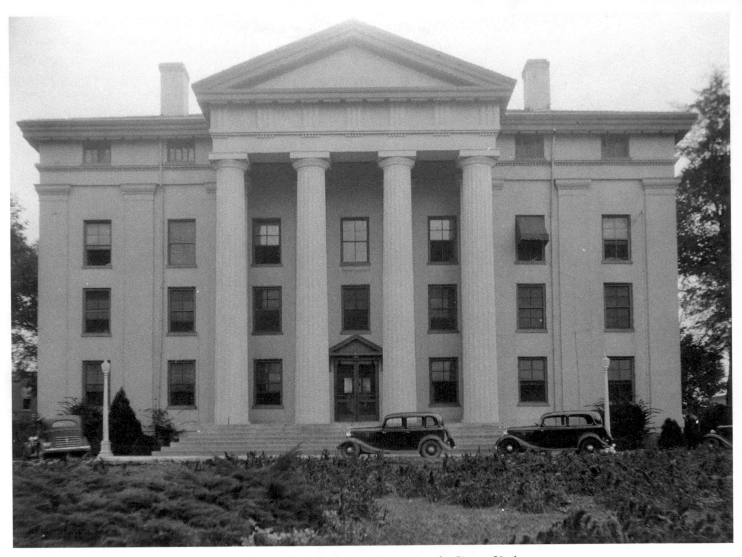

Shown here on September 7, 1936, Jackson's City Hall was built in 1847. During the Siege of Jackson in July 1863, Sherman's forces burned the city to the ground, sparing few of Jackson's public buildings. City Hall was among them, perhaps because it housed an army hospital during the war.

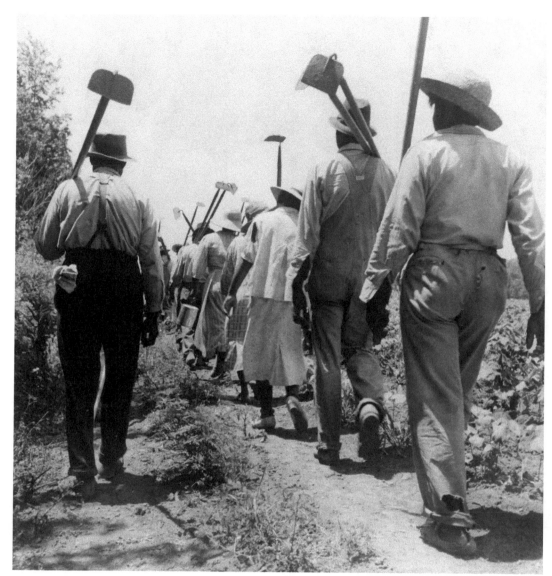

In summer 1937, laborers at Clarksdale, in Coahoma County, head for the cotton fields around six o'clock in the morning to begin a long day of hoeing cotton.

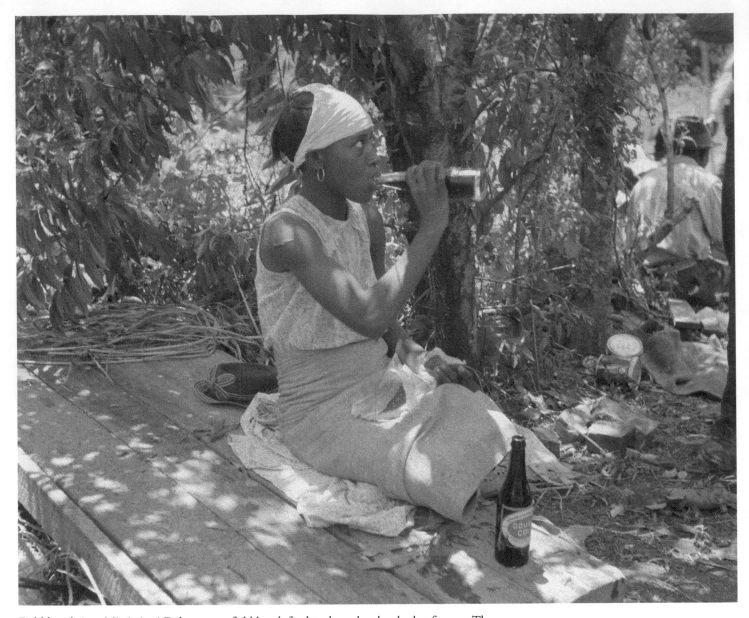

Field hands in a Mississippi Delta cotton field break for lunch under the shade of a tree. The young woman at front is having a Double Cola, a soft drink widely available in the South beginning in the 1930s.

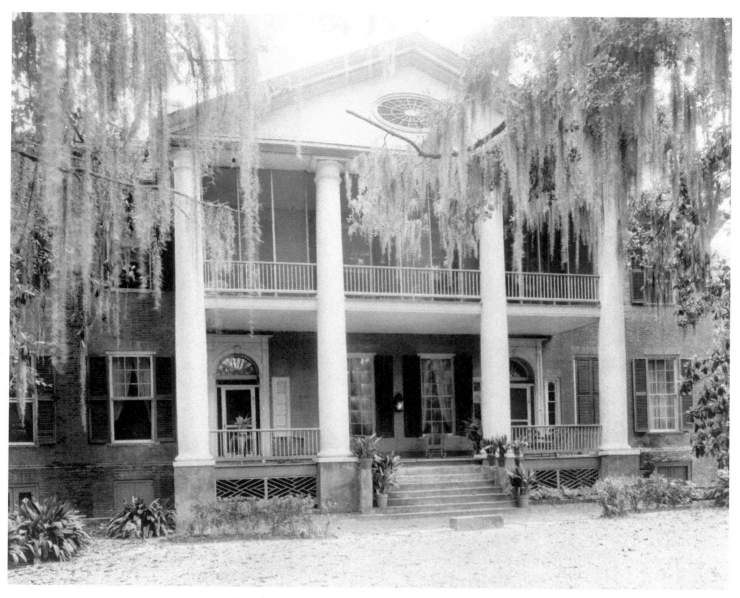

Spanish moss hangs from live oaks and magnolia, which adorn the yard of this elegant, timeworn Mississippi home in Adams County. The evergreen magnolia, filled with fragrant, white blossoms during part of the year, is abundant in the South and is particularly fond of the Magnolia State. The magnolia has been the state tree since 1938, and is also the state flower.

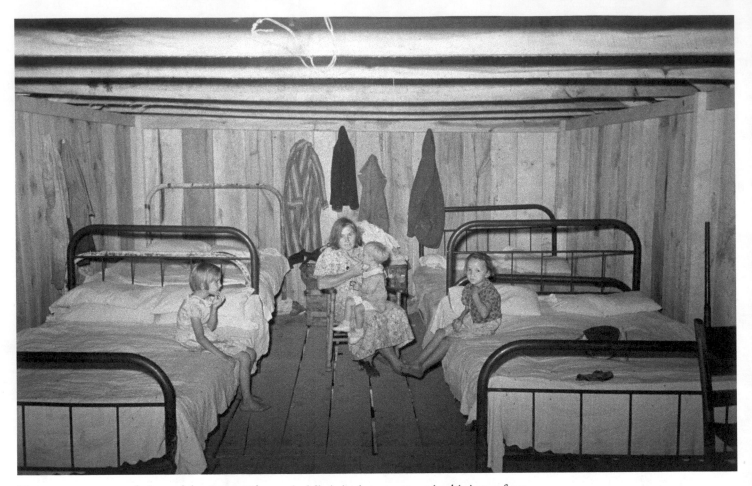

The spartan accommodations of sharecropper homes in Mississippi are apparent in this image from May 1938.

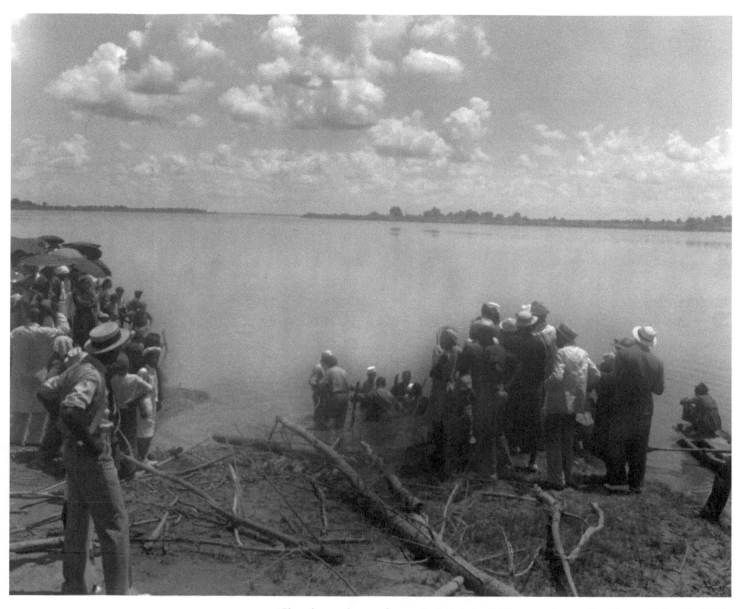

Church members gather at the Mississippi River to witness a baptism on May 29, 1938.

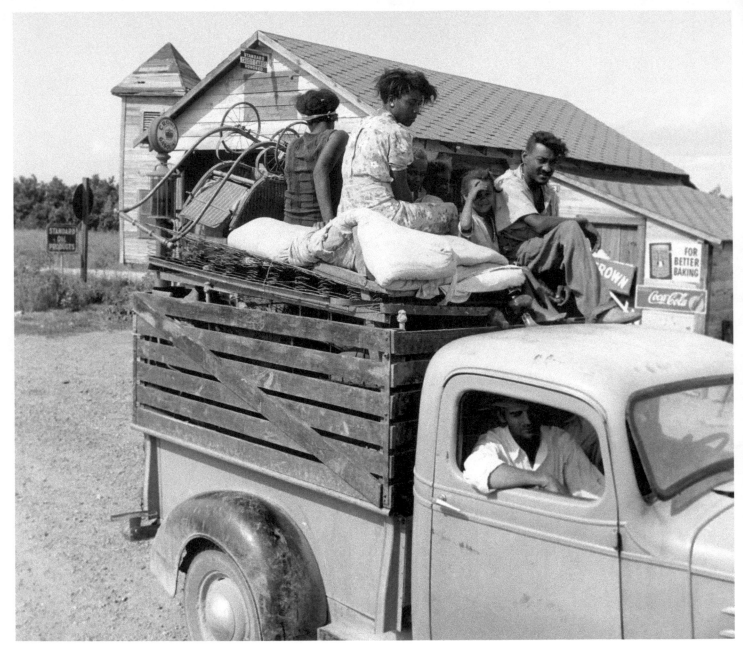

On moving day in June 1938, a laborer's family moves from Arkansas to Mississippi. The loaded truck is parked at a filling station along Highway 1 between Greenville and Clarksdale.

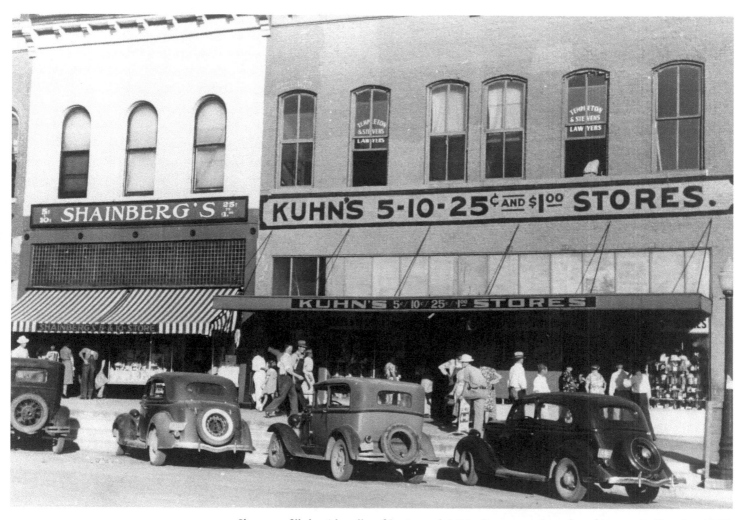

Shoppers fill the sidewalks of Lexington's Main Street on a Saturday afternoon in October 1939. Kuhn's and Shainberg's five and dimes are open for business. The "five and dime" had become a very popular kind of retail outlet throughout the nation.

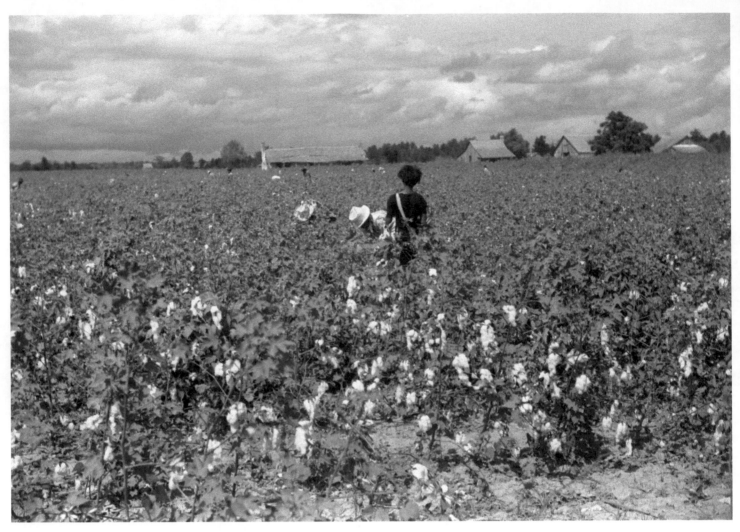

It's cotton-picking time in October 1939 at Nugent Plantation, in Benoit.

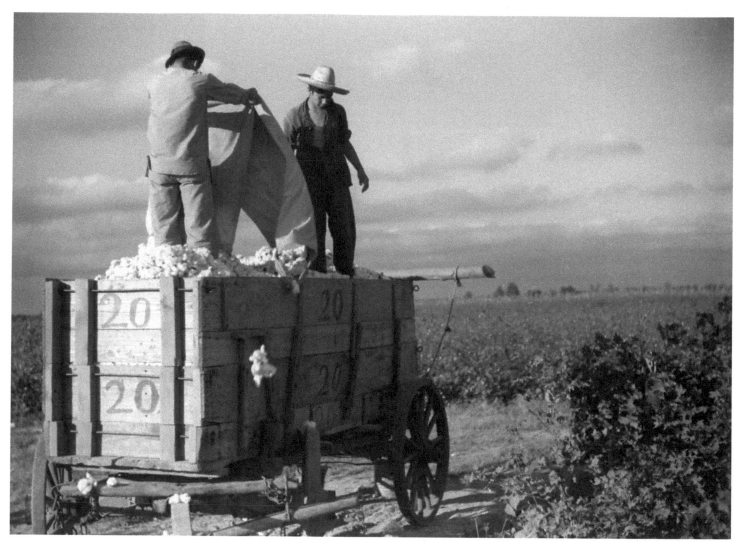

Laborers fill a wagon with cotton in a field at Knowlton Plantation, in Perthshire.

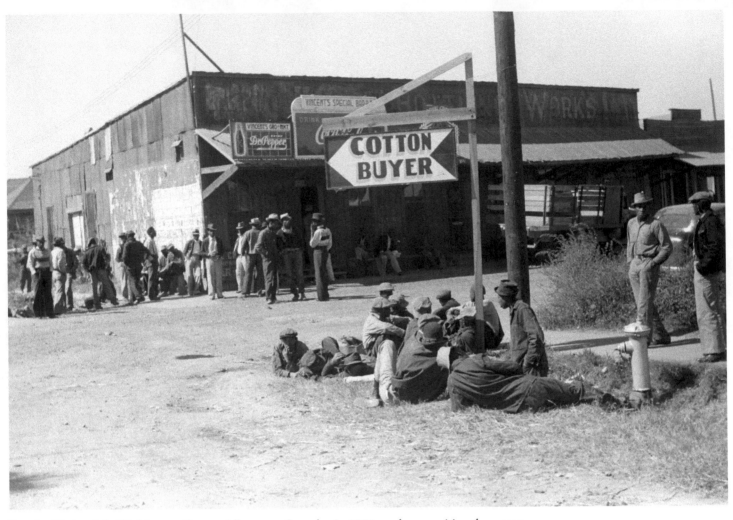

Locals of Belzoni, in Washington County, idle away a Saturday in 1939, perhaps awaiting the cotton buyer.

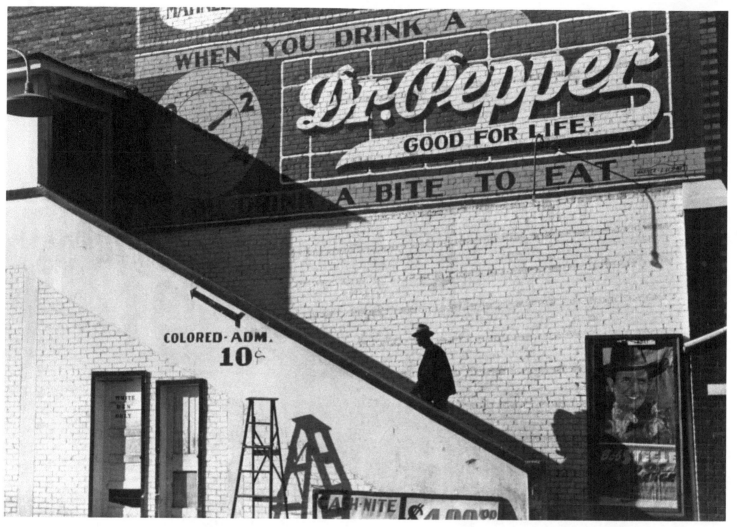

A Bob Steele western attracts a Belzoni moviegoer, who climbs the stairs to a Saturday matinee during the era of segregation.

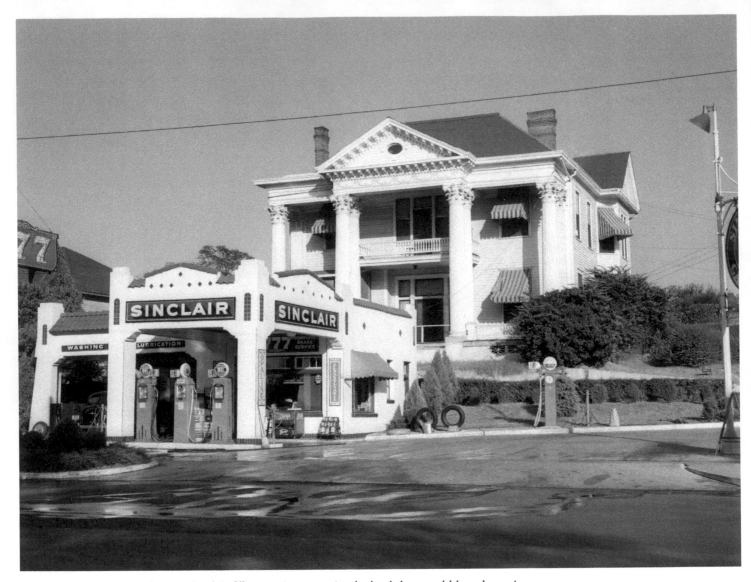

In November 1939 at Jackson, a Sinclair filling station occupies the land that would have been, in an earlier day, the front lawn of the historic home at rear. Filling stations of the era were carefully designed, often featuring terra cotta roofing and other refinements. The photographer's question, perhaps, is whether the architecture of this station both mimicks and compliments the stately columns, handsome portico, and other features of the aging mansion.

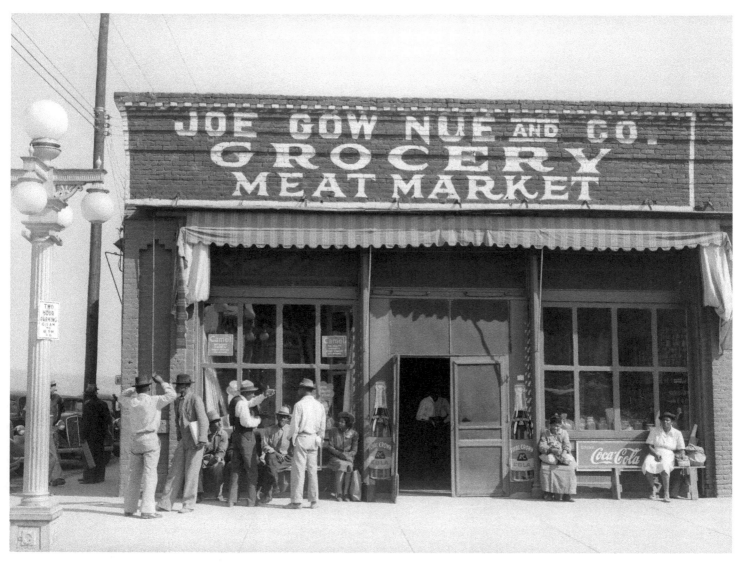

Joe Gow Nue and Company Grocery and Meat Market is open for business in November 1939. Signage limits parking to two hours, and a window ad announces that Camel is the "quality cigarette every smoker can afford."

In November 1939, it is all about cotton on Cotton Row Street in Leland.

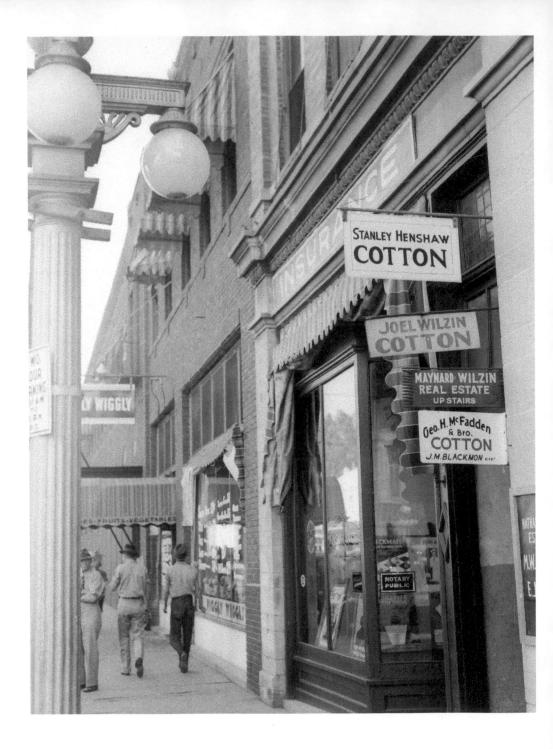

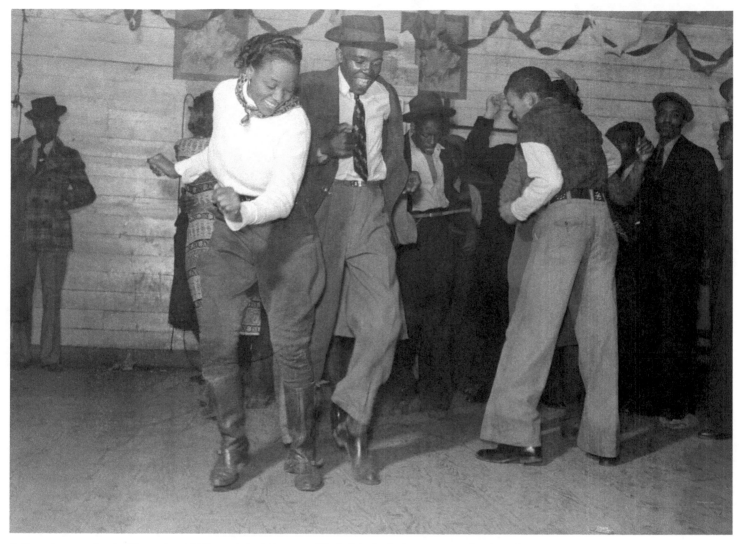

A Saturday evening in November 1939 at a juke joint near Clarksdale finds these patrons hard at play, jitterbugging. Wearing their best clothes, all participants seem to be having a very good time.

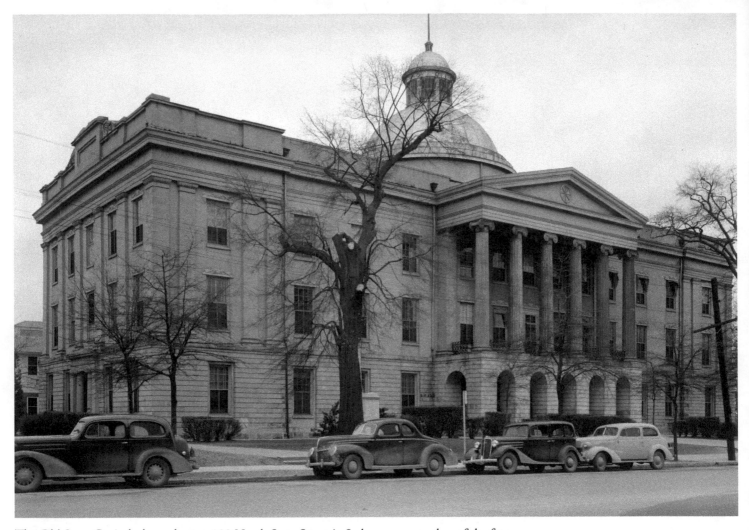

The Old State Capitol, shown here at 100 North State Street in Jackson, was another of the few structures to survive when Union forces under General Sherman torched the city during the Civil War. The structure is an excellent example of Greek revival, conceived and erected on a monumental scale. The Capitol was the seat of government for the State of Mississippi from 1839 to 1903, when it was replaced with the new capitol.

WAR IN EUROPE AND STRUGGLES AT HOME

(1940–1950s)

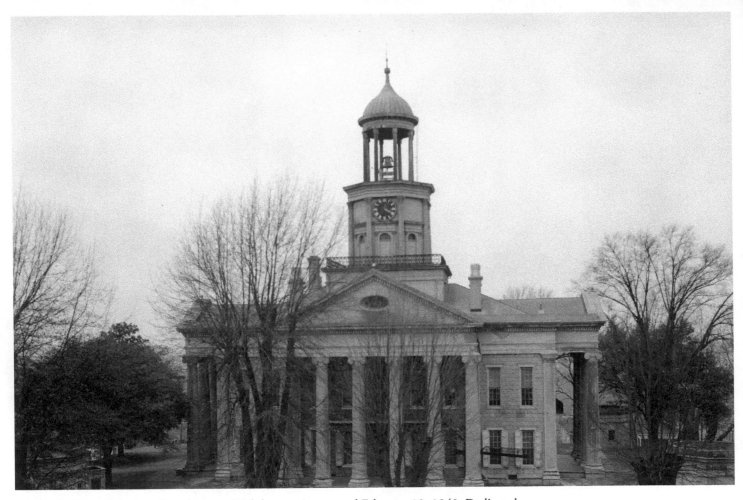

This is the Warren County Courthouse at Vicksburg as it appeared February 19, 1940. Dedicated June 16, 1858, the structure survived the 47-day siege during the Civil War, and it was here that the forces of General Grant brought down the Confederate flag at the fall of Vicksburg.

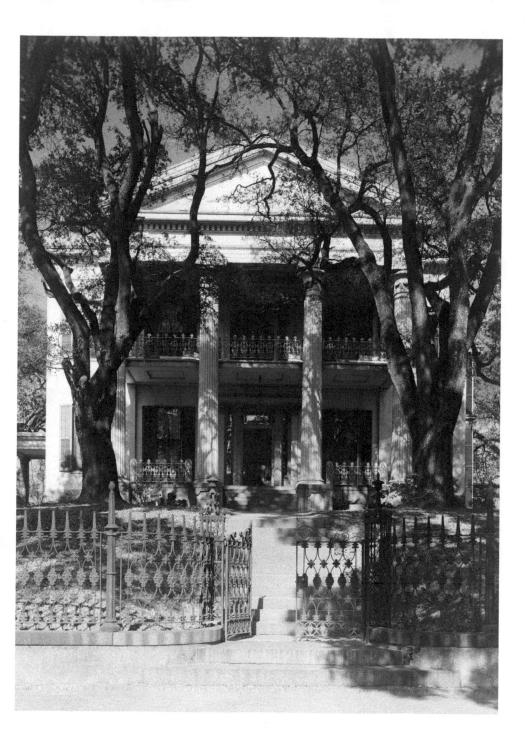

Stanton Hall at Natchez as it appeared in February 1940. The princely mansion, once owned by Irish immigrant Frederick Stanton, is one of the grandest in Mississippi. The massive white palace with immense Corinthian columns and wrought-iron fencing encompasses a full city block downtown.

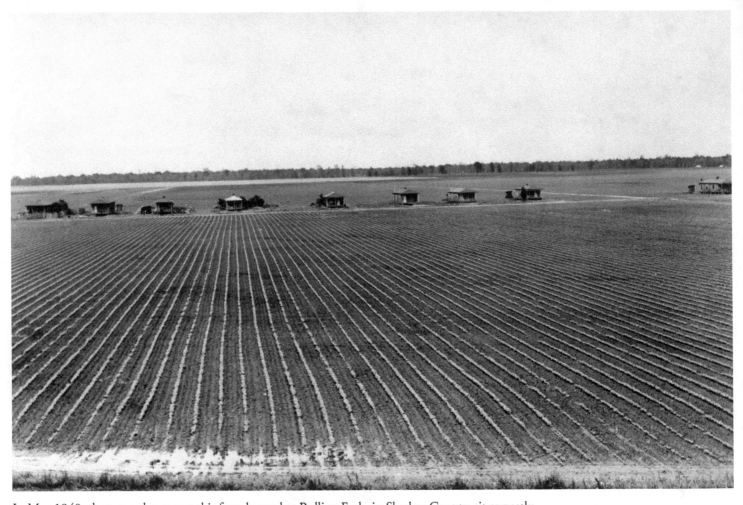

In May 1940, the tenant houses on this farm located at Rolling Fork, in Sharkey County, sit as neatly in line as the rows of cotton in the front of each one. Despite boll weevil infestations in foregoing decades, cotton remained a key to Mississippi agriculture.

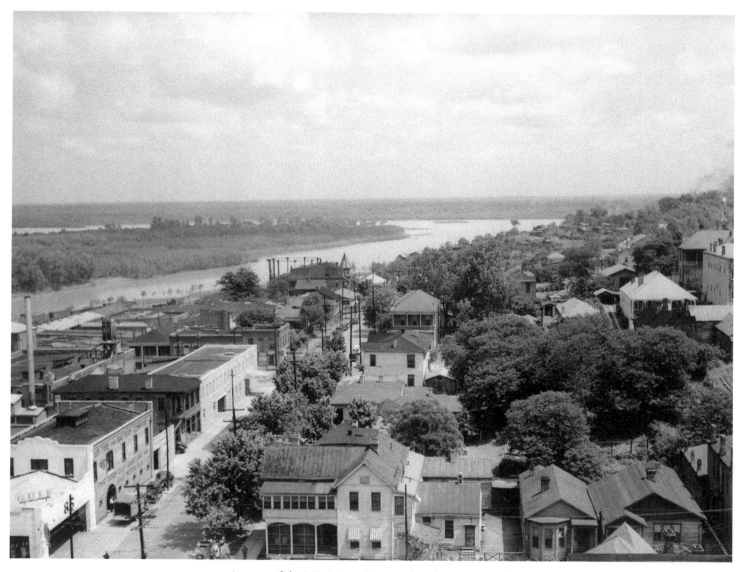

An arm of the Mississippi River snakes through Vicksburg in this bird's-eye view from May 1940.

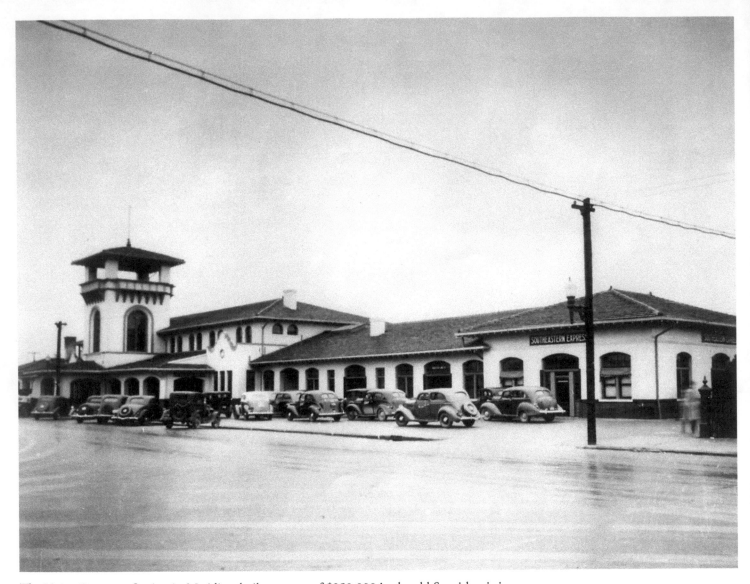

The Union Passenger Station in Meridian, built at a cost of $250,000 in the old Spanish mission architectural style, was fully operational by 1907. The station fronted three city blocks, and three train sheds next to the depot accommodated dozens of passenger trains each day. Railroads were pivotal to the growth and development of east central Mississippi.

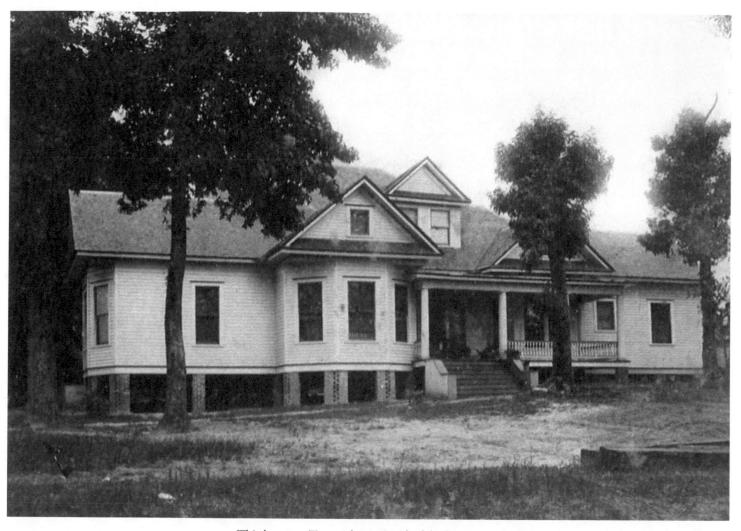

This house at Toomsuba, in Lauderdale County, once provided a lovely home for a large family. Bolstered by the timber business, the hamlet of Toomsuba was a thriving community during the late 1800s and into the 1900s with churches, schools, and a lively atmosphere.

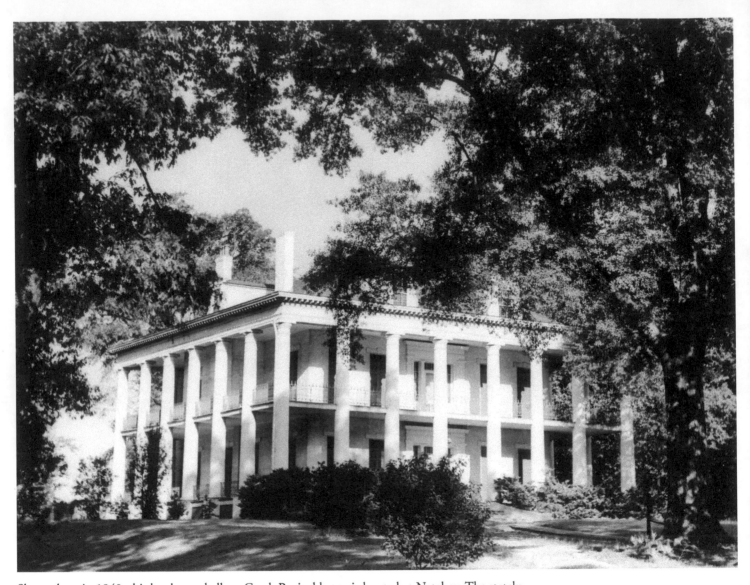

Shown here in 1940, this lovely antebellum Greek Revival house is located at Natchez. The stately home was built in 1856 and is the last surviving example of a fully colonnaded house in Mississippi. Alfred Vidal Davis purchased the house for $30,000 in 1859 and gave it the Scottish name Dunleith.

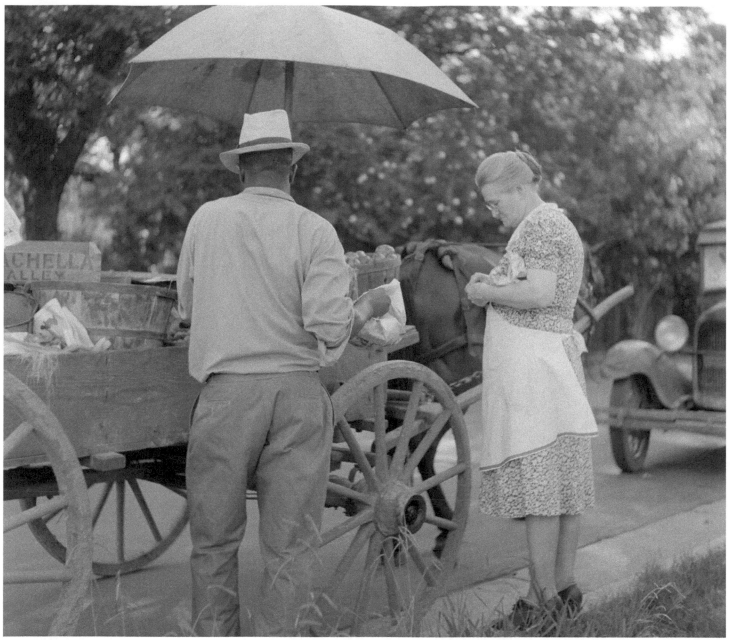

"Peas, beans, 'maters, and corn" calls the vegetable man in this Natchez neighborhood. The grandmotherly customer counts her pennies carefully as she buys fresh vegetables for the family.

An off-duty scene of fun and frivolity breaks out at Camp Shelby in Hattiesburg in June 1943. The dance was held for service personnel stationed here. As Americans of Japanese descent, the soldiers were members of the 442nd Combat Team, and the girls hailed from the Jerome and Rohwer Relocation Center in Arkansas, an internment camp. At front, Private Harry Hamada tries the hula as the band plucks the lap steel guitar and the ukulele.

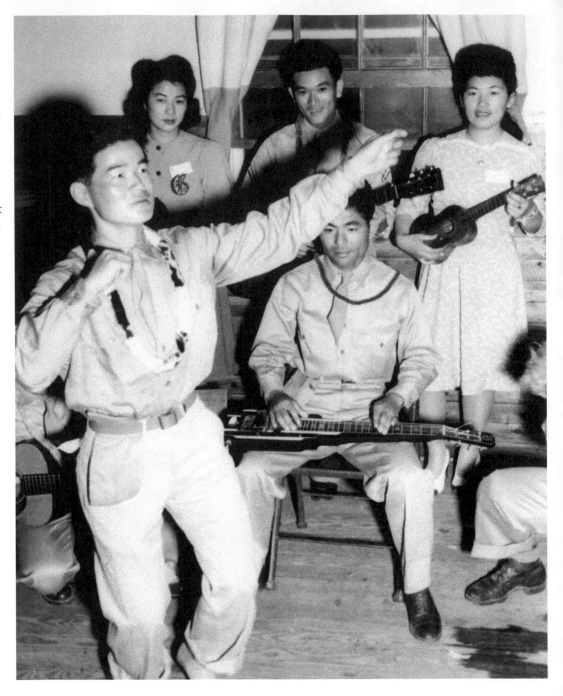

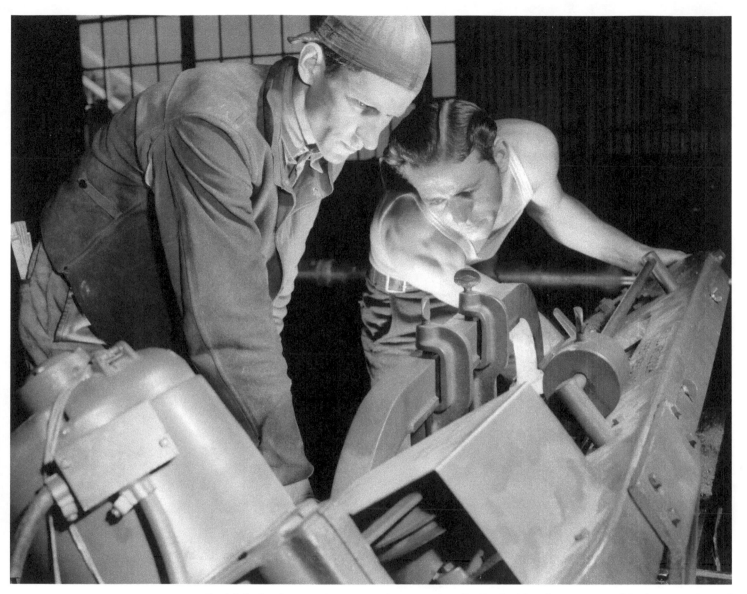

Established at Pascagoula in December 1938, Ingalls Shipbuilding became one of the largest industrial employers in the nation during World War II. Wartime job opportunities brought a basic change in the character of the state's rural population as droves of Mississippians left the farm to train for jobs with employers like Ingalls. These men are working at Ingalls in May 1942, just five months after the attack on Pearl Harbor.

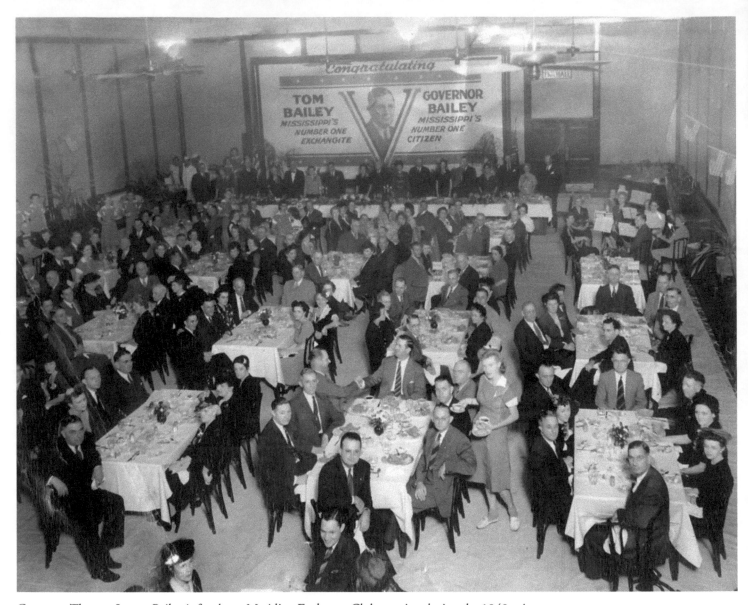

Governor Thomas Lowry Bailey is feted at a Meridian Exchange Club meeting during the 1940s. A resident of east central Mississippi, Bailey was elected to the legislature in 1915 and served there more than 20 years. He was Speaker of the House by 1927 and served as Mississippi governor from 1944 until his death in 1946. Bailey supported a progressive Mississippi with improvements to education, agricultural methods, and medical care.

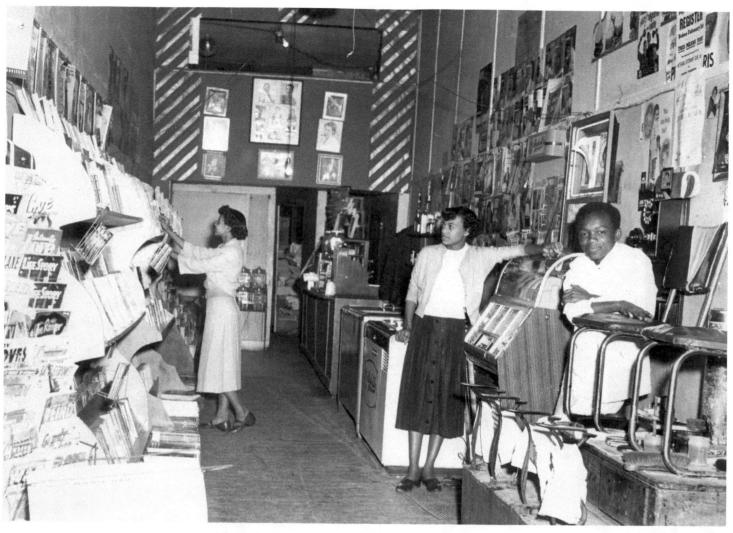

A busy day is in progress in the 1950s at the Farish Street Newsstand and Studio in Jackson. Shown are two clerks waiting to greet customers and one woman selecting a magazine.

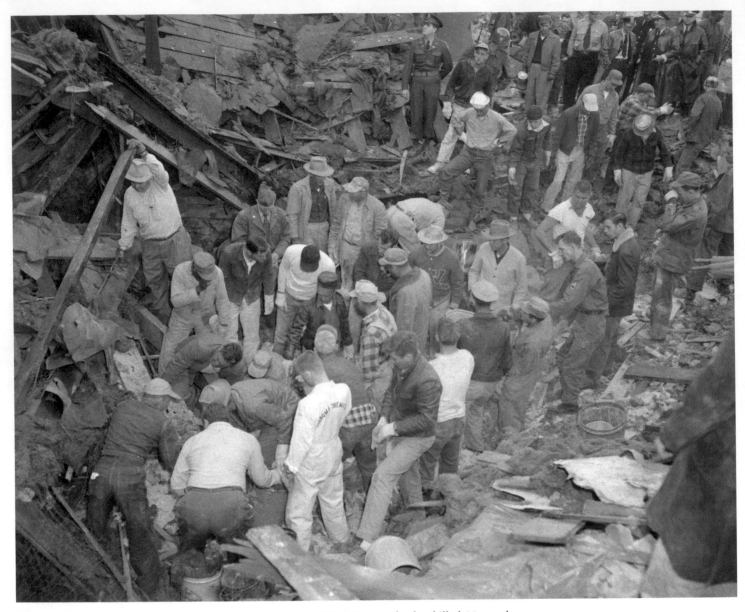

Rescue efforts are ramping up following the December 5, 1953, F5 tornado that killed 38 people and destroyed many structures in Vicksburg. Mississippi ranks second among the states for tornado fatalities and third for injuries. In 1953, 22 tornadoes whirled through the state, causing 39 deaths, 310 injuries, and damages of $66,466,880.

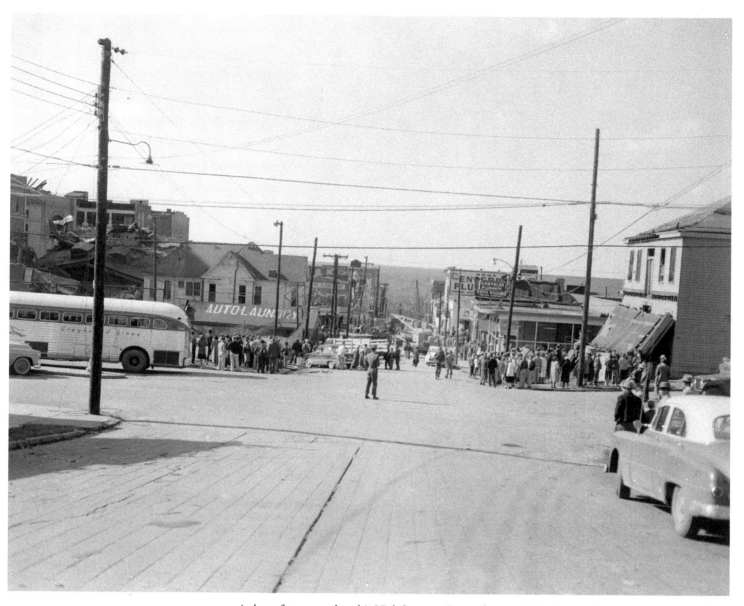

At least four tornadoes hit Vicksburg on December 5, 1953. Twelve blocks of the city's business district suffered extensive damage, the city's gas line was broken, and fires broke out throughout the area.

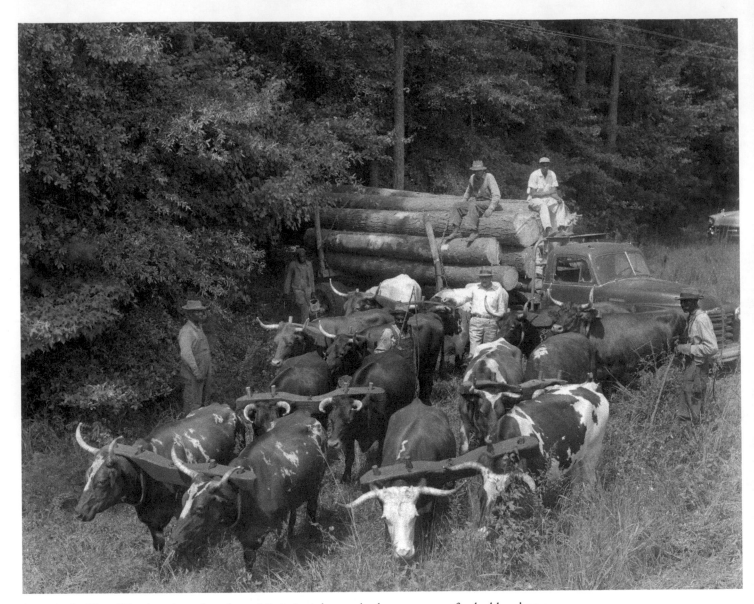

Deep in the Piney Woods region of southeast Mississippi, loggers lead seven teams of yoked longhorns to a truck in 1958. Logging was the original impetus for the establishment of many communities in Mississippi and continues as a leading industry in the state. Many of the original logging roads became major highways with the passage of time. The Piney Woods area gets its name from the longleaf pine tree that grows there.

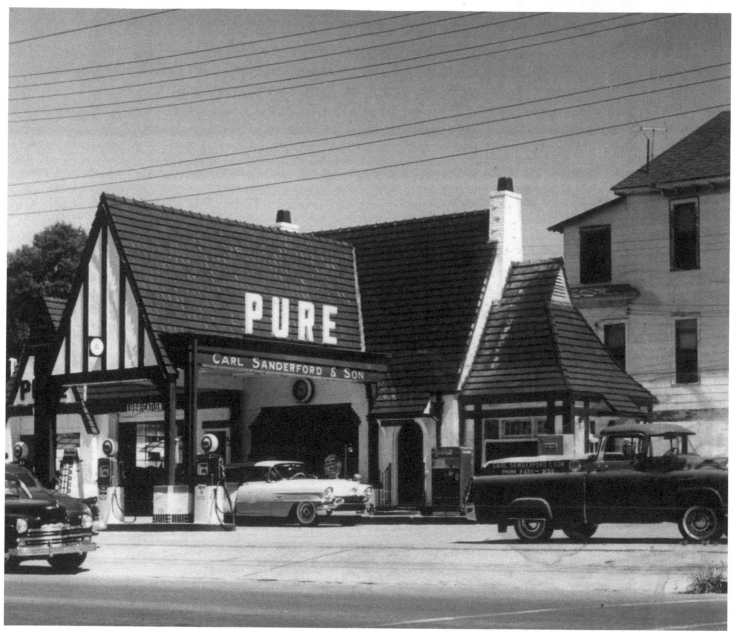

Carl Sanderford and Son are "hitting on all eight" as proprietors of this booming full-service filling station in the 1950s. Once upon a time, American automobiles were manufactured with eight cylinder engines as a standard feature.

Notes on the Photographs

These notes, listed by page number, attempt to include all aspects known of the photographs. Each of the photographs is identified by the page number, a title or description, photographer and collection, archive, and call or box number when applicable. Although every attempt was made to collect all data, in some cases complete data may have been unavailable due to the age and condition of some of the photographs and records.

Printed in the USA
CPSIA information can be obtained
at www.ICGtesting.com
JSHW072025140824
68134JS00042B/3785